Modern Painting

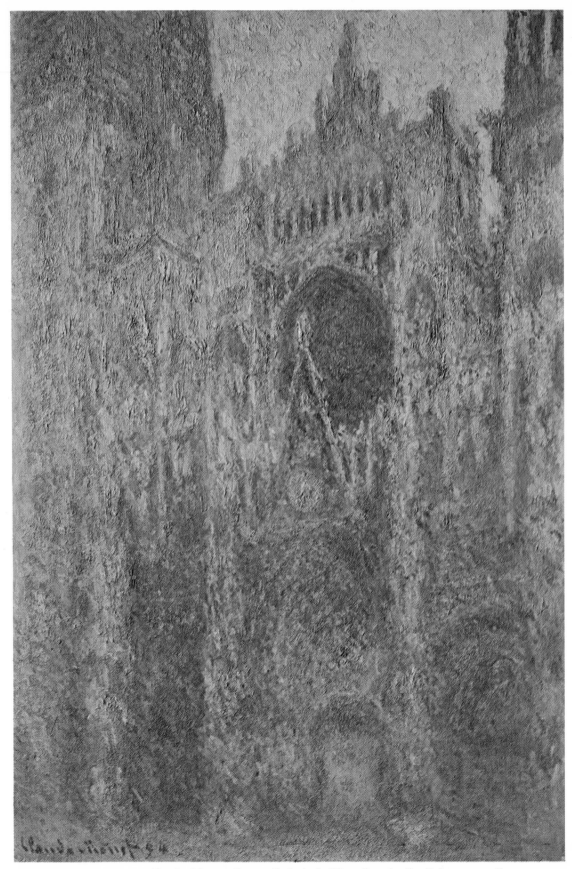

Claude Monet *Rouen Cathedral, West Facade, Sunlight* 1894, oil on canvas,
National Gallery of Art, Washington, D.C. (Chester Dale collection).

Modern Painting

the movements

the artists

their work

by Burton Wasserman

Professor of Art, Glassboro State College, New Jersey

Davis Publications, Inc. *Worcester, Massachusetts*

Consulting Editors: Sarita R. Rainey and George F. Horn

Copyright 1970
Davis Publications, Inc.
Worcester, Massachusetts, U.S.A.

Library of Congress Catalog Card Number: 72-108885
ISBN: 0-87192-033-6

Printing: Davis Press, Inc.

Type: Monotype Bell

Design: Panagiota Darras

10 9 8 7 6 5 4 3 2

Preface

What is modern painting all about and what does it mean are two important questions frequently asked by youngsters and adults alike. Of all people, art teachers especially should be able to answer these questions if they wish to help students gain an understanding of, and appreciation for, the art of our time. Without such understanding it is difficult for anybody to see the relevance of contemporary art to their own time and frame of reference.

It has been said that art is the mirror of the time in which it is created and, in this sense, modern art is particularly relevant to the kinds of concerns being expressed by students in our schools today. If students are to see the relevance of art to their concerns, teachers must understand the implications of the major art movements of our time. To assist us in gaining such understanding, Burton Wasserman has traced the chronological development of the major movements in contemporary art from the days of Impressionism through what is current in today's gallery scene. More than just providing us with a listing of these important art epochs, he has developed a conceptual framework through which we can not only see distinct relationships between epochs, but also how the various periods have influenced each other.

Beginning with the roots of modern art, Impressionism and Post Impressionism as exemplified in the work of van Gogh, Gauguin, Seurat, and Cézanne, the author explores the evolution of these directions into Fauvism, Expressionism, and Cubism. Identified in detail are the important ancillary outcomes of Dada, Fantastic Art and Surrealism which have refined traditional Modernism into the most immediate developments evidenced today in Pop, Op, and Kinetic art. Despite the profusion of styles and contrasting esthetics attached to these varied art forms, Burton Wasserman successfully closes the gap between the reader and the studio painter who struggles with the legacies of the modern tradition.

According to the official position paper of the National Art Education

Association: *The Essentials of a Quality School Art Program*, art in the school program includes four important aspects: seeing and feeling visual relationships, producing works of art, knowing and understanding about art objects, and evaluating objects. It is to these ends that Burton Wasserman's text is directed, that is, to help those responsible for creative esthetic education to acquire the understanding necessary to effect these four important aspects of the school art program. Furthermore, his text focuses specifically on the attainment of those objectives which seek to assist students in acquiring knowledge of man's visual art heritage, to make intelligent visual judgments, and to understand the nature of art and the creative process—objectives too often neglected in many elementary and secondary school art programs in our country. What makes this text particularly unique is the author's interpretation of the contemporary art scene which is, as a rule, the period most often misunderstood and neglected in texts dealing with the history of art. *Modern Painting: the Movements, the Artists, their Work* is planned to help readers gain important insights into the world of contemporary art. It is written in a unique style which appeals to both the trained art professional and the classroom teacher. Though academically sound in its treatment of both artists and art epochs, the text avoids unnecessary pedantry and obtuse scholarliness in order that the reader may acquire a sound understanding of what contemporary artists are really attempting to accomplish in their work. The text will be especially meaningful to those who are sincerely baffled by the names of such art movements as Surrealism, Cubism, Dada, Expressionism, Pop, and other similar terms which today characterize certain periods in the development of contemporary art. For those who feel a real desire to find out why and how these movements came into being and wish to understand the changes which have come about in the visual arts in the past one hundred years, this book will be particularly meaningful and enlightening.

Because Burton Wasserman is no stranger to either the field of art or art education, he is uniquely qualified to author this particular text. As a painter and graphic artist, his work is well known in many U.S. museums and galleries. As a writer and contributing editor to ART EDUCATION, the official *Journal of the National Art Education Association*, his views on art and art education are well known to art teachers at all professional levels throughout the United States and Canada. It is with a good deal of personal and professional pride that I welcome this new book which will bring knowledge and expertise to many people who have not previously had the opportunity to share the author's unique insights into the world of art.

Charles M. Dorn
Executive Secretary
National Art Education Association

Washington, D.C.
1970

Foreword

Modern painting brings satisfaction and pleasure to multitudes of people all over the earth. It isn't hard to understand why. When colors, shapes, textures, and spaces are sensitively organized and charged with countless kinds of meaning they are capable of exciting our senses, engaging our intellect, and giving our emotions a workout quite like nothing else under the sun.

Of course, there are those who disagree. They complain that the venturesome and frequently unfamiliar art of our time is a jumble of confusion and disorder whose only purpose is to bedevil an unsuspecting public.

Perhaps the heart of the matter is the plain fact that modern painting is not simple. It is rather like a complex landscape; within the vastness of its space so much has been going on—especially since the turn of the century. At times, the changes of direction may seem staggering because they have taken off almost out of nowhere. The changes and the speed with which they sometimes occur have no precedent in any previous century. But then, everything else about our time is unmatched by any previous period in the past. Just as medicine and physics today have become incredibly advanced and complex, painting in this day and age has also become more complicated and sophisticated than it ever was before. Perhaps that is why modern painting is more interesting and many-sided than painting could ever be in any previous era of human experience. Yet, the central problem remains. In order to get very much out of modern painting you have to know something about why it came into being. In a nutshell, that is what this book is about.

My own contact with modern painting has repeatedly enriched me in ways that are beyond measure and description. Because modern painting has given so much to me I feel a debt of gratitude which can be repaid only by sharing what I have learned with other people who also want to enjoy what modern painting has in store for them.

This book is therefore written for everyone—the student, teacher,

librarian, and of course, the general reader—looking for some basic guidelines with which to discover how and why modern artists have made deeply expressive works which illuminate the most fundamental realities of life in the twentieth century.

At this point a very important note of caution needs to be mentioned. It concerns the danger of substituting words about art for direct contact with art. The pages that follow aim to be as helpful and informative as they can be. If they are of any real value they will light a way toward what must finally happen if any genuinely worthwhile art experience is to take place and that is to get close to actual paintings. Reading about the work of painters must never be allowed to replace the process of truly seeing their work. Obviously, artists speak in a language of vision and it is only in seeing what they have to say that you may share in their efforts and benefit from the exercise of their craft.

Another danger that frequently crops up with art appreciation is the tendency to be satisfied with what might be called: *Instant Culture*. For works of art to be personally significant you must be willing to invest time and effort in establishing a rapport with those works. However, to be *deeply* touched and moved by art requires more than cursory reading or hearing an oversimplified explanation of what a particular work deals with. Further background study—in depth—is necessary if works are to be seen and understood in the totality of a given time and place in history.

No book I know of has ever been prepared without lots and lots of help, encouragement, and the cooperation of many kind and thoughtful people. This one is no exception. And so, I want to take this opportunity to sincerely offer my heartfelt thanks to everyone connected directly and indirectly with the project. I believe that this also is the place where I may properly express my appreciation to Charles Dorn, George Horn, Bill Jennison, Sarita Rainey, my son Marc, and my *lieber Meister*, Arthur R. Young for the inspiration and counsel they have all provided at various times in the past as well as the present. I want to especially thank Dorothy Boyer for her endless patience and my wife Sarah for her continued interest, understanding, and good humor.

One last point needs to be noted. It consists of an apology to all the artists whose work should have been mentioned but who were, somehow, left out. A small book like this can cover only so much ground. What was selected for inclusion must reflect the prejudices and inadequacies of the person who made the selection. I have tried to do the job the best way I knew how. If any serious sins of omission have been committed, the responsibility for such errors is entirely mine.

B. W.

Glassboro, New Jersey
1970

Contents

Color plates

1 | Impressionism — educating our eyes to see what we had been missing

Today we take *Impressionism* pretty much for granted. It seems so tame and decoratively beautiful. We find it difficult to believe there was a time when *Impressionism* was the most revolutionary direction in Western art.

Impressionism marks the great break with the art of the past. Whatever is modern in modern painting stems directly from the new realities created by the painters of the Impressionist school. While they represented a development from their immediate predecessors they did, in fact, evolve a way of thinking and feeling about art that was virtually unlike anything that had ever come before.

The very word *Impressionism* was originally coined in a spirit of ridicule. It began in 1874. An independent exhibition was held in Paris by a group of painters. By and large, their work had only been accepted irregularly by juries of the Salon, the officially sanctioned, conservatively oriented exhibition held annually in France. Claude Monet, Auguste Renoir, Camille Pissarro, Alfred Sisley, and Edgar Degas were among the artists who participated in the exhibition. Their work was reviewed by a writer named Louis Leroy in *Le Charivari*, a satirical magazine. In derision, he called the artists "impressionists" after making light of a particular picture by Monet called *Impression, Sunrise*. His point was that the painters were failures because their work did not look like the familiar, academic pictures he expected to see at an exhibition. The review was a sensation. People soon flocked in droves to see the show and laugh at what they saw. They were amused by what the artists considered to be their best finished pictures. As spectators at an exhibition they felt that the painters had made sloppy sketches which they were then trying to pass off as "finished" paintings. In addition, many who

came to look at the work on view complained that their eyes hurt from looking at what they considered to be rather raw, harsh colors. The general public of that day simply refused to take what they saw seriously as art. To them it was just a wild joke, in bad taste, perpetrated by overgrown children with no ability for making art.

The name *Impressionism* stuck. We still use it today because it is a handy reference—even though it does not really tell us much about what the artists in the group were up to or why they did what they did.

"Well," we may ask, "What did they achieve?" Mostly, they poured fresh, new life into the old, tired art of painting. In very practical terms they recreated what painting was all about.

Monet, for example, took his paints and canvas out of the studio and into the field. When he painted a landscape or the facade of a cathedral he actually looked at his subject matter. He took time to carefully study what he saw. Beyond anything else, he found that the appearance of everything his eyes could see underwent continuous change as the light and atmosphere around him kept changing.

If he looked at haystacks in a meadow he discovered that their appearance varied as the sun moved through the sky. They looked different at four o'clock in the afternoon than they did at nine o'clock in the morning. In addition, their appearance would be radically altered by whether the light of the sun came through a clear sky or was affected by haze, fog, or clouds. In short, he found that the forms we see with our eyes are revealed to us by the play of light and atmosphere upon the forms. Now, that seems perfectly sensible. And, of course, it is. But, in the third quarter of the 19th century, people interested in art actually found that hard to believe. For centuries, artists had painted subject matter virtually as though its appearance was always the same. As a consequence, the art public believed that the appearance of any subject was indeed constant. They never stopped to question that belief. Instead, they presumed that just because they *thought* something was true it really was true. They never stopped to ask themselves if they might be mistaken.

Monet's art teaches our eyes to see the world with a whole new look. If we can learn from what he has to show in his pictures we may come to see everything around us with a fresh perspective.

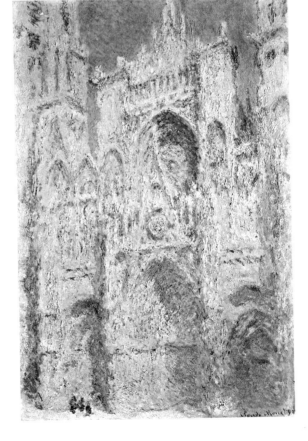

1 Claude Monet *Rouen Cathedral, West Facade, Sunlight* 1894, oil on canvas, National Gallery of Art, Washington, D.C. (Chester Dale collection). Light and atmosphere, rendered with luminous colors and rich strokes of paint, bring out the appearance of sunshine glowing warmly on the front entrance to the church. See frontispiece color plate.

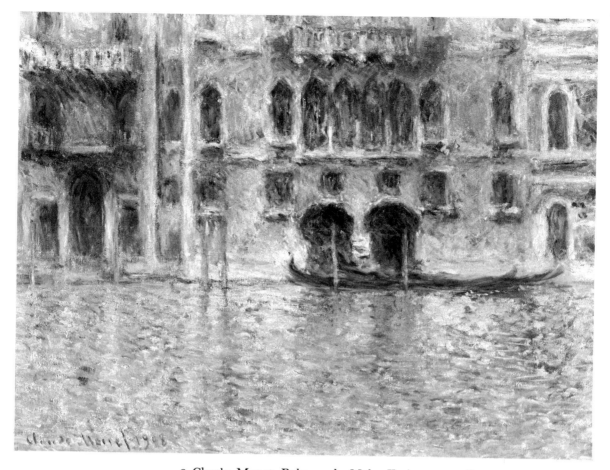

2 Claude Monet *Palazzo da Mula, Venice* 1908, oil on canvas, National Gallery of Art, Washington, D.C. (Chester Dale collection). Horizontal and vertical areas compliment each other and radiate a shimmering brightness upon the canvas surface.

We may see that there are no lines drawn around forms in nature. The outline drawings we often see in art are merely a visual shorthand or abstraction. The real (and continuously changing) form of objects depends upon the colors of the objects. In turn, the colors are modified by the light that strikes them, by reflections from surrounding objects, and by the overall atmosphere in which the objects are viewed. Shadows actually seem to be low-key notes of color opposite in hue to the color(s) in the objects being seen. For this reason Monet eliminated black from his palette as did many of his associates.

Of course, Monet provides us with more than visual journalism alone. Furthermore, he was not simply a prophet whose work foretold the coming of the color camera. Above all else, Monet was an artist. His paintings are not merely ordinary perceptions. Instead,

they are intensely powerful perceptions—filled with richness and vitality in paint. His brushwork was rapid—the strokes, unmistakably made of pigments ground in oil—are heavy and juicy in their build-up on the canvas surface. Each application of color catches and holds a momentary glimmer of light or a reflection from something nearby. That is why his *Impressionism* looks at first like a patchwork of thick, paste-like paint splotches. You have to step back and view them from a distance. Suddenly, they come into focus and blend together upon your retina, the sensitive back wall inside of your eyeball. There, the ragged edges of the brush strokes come together and merge into a grand composite mosaic of color. Because the strokes are not overly brushed into each other the whole painting invariably comes alive with a remarkable spontaneity unlike anything else in the world. Tones and tints are seen to shift and glow. An area may vibrate and shimmer in a display of sunlight. Another picture may be soft and silent as early morning mist drifts across the scene. And in still another work you may find Monet has intensified notes of color by placing specks and strokes of complementary

3 Claude Monet *Banks of the Seine, Vetheuil* oil on canvas, National Gallery of Art, Washington, D.C. (Chester Dale collection). Flowers in the foreground and distant trees on the horizon join together in a composition that is completely calm and gently restful.

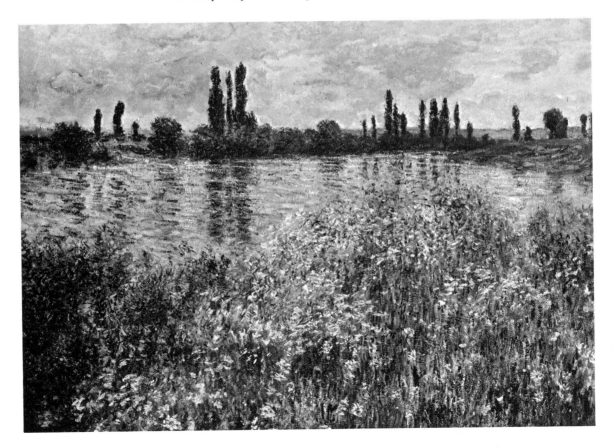

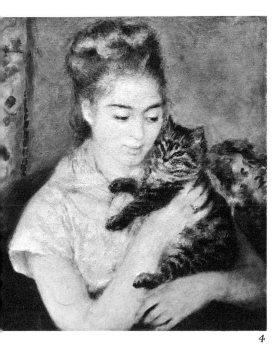

4

(opposite) colors into the picture. For example, some greens may be heightened in their impact because of the presence of some orange-reds placed in the same vicinity. The more you look and question, the more you may come to see and learn.

The artists of the Impressionist School did not make carbon copies of each other's work. Each one evolved an identity of his own. Renoir found satisfaction and delight in everything he chose to paint. Even when he had to endure privation and financial disadvantage he managed to retain an optimistic outlook on life. His pictures of children, flowers, or adults glisten with a very special kind of glow. His eyes could discover radiance and warmth wherever he would look. Like Monet he felt no need to paint especially significant subject matter. He could make any subject matter become important. His art was not dependent upon *what* he painted but rather *how* he painted. The touch of his brush was filled with magic as well as an abundance of scintillating, shimmering color.

Particularly in his late paintings, Renoir's pictures of women are deeply resonant orchestrations of intensely saturated pigment. The figures are allegorical daughters of Mother Earth. In a language of paint they speak eloquently of the high regard and respect Renoir felt for the fruitfulness of nature.

In his most mature period of production, Renoir put color to work modeling a monumental sense of solidity. He was especially adept at building shapes in space using the tendency of certain colors to come forward while other colors in the same canvas seem to recede. For example, a light, warm yellow may appear to be out in front of a cool, dark blue even though they are both really on the same surface. This ability to articulate volume proved to be very influential upon the thinking of certain artists, like Cézanne, who followed Renoir.

In contrast to Monet and Renoir, Degas did not place his greatest emphasis on out-of-doors subject matter. Furthermore, unlike most of his Impressionist colleagues, he retained both the color black and contour lines even though neither one of them really exists in nature.

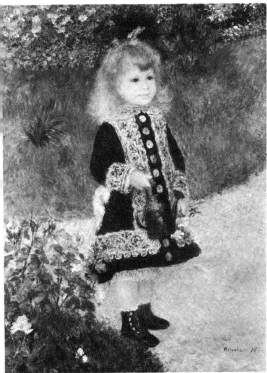

5

4 Auguste Renoir *Woman with a Cat* oil on canvas, National Gallery of Art, Washington, D.C. (Gift of Mr. and Mrs. Benjamin E. Levy). The varied textures and colors of skin, hair, cloth, and cat fur come alive in subtle notes of paint spread out across the total area of the canvas.

5 Auguste Renoir *A Girl with a Watering Can* 1876, oil on canvas, National Gallery of Art, Washington, D.C. (Chester Dale collection). Renoir's regard for the tenderness and innocence of childhood comes through so clearly in this picture of a relaxed little girl located within a garden setting.

Still, he associated with the Impressionists because of his profound concern for color and direct observation.

Degas took incredibly great pains to capture and preserve the freshness of a momentary glimpse. His pictures are filled with a feeling of close-up, candid immediacy. We look into what he has to show and we are there, on the scene seeing what he has seen with his eyes. He shows us so much we otherwise might have missed because he has sifted through the subject and filtered out the non-essentials.

Degas had an eye for the unexpected—for the sudden, impulsive gesture and the turning movement. In the unpostured natural pose he found a way to express a genuine, down-to-earth, believable human reality. Like Monet and Renoir, the art of Degas educates our sensibilities. When we study his art we become more perceptive —more aware of what there is to be seen in the world around us.

In addition to oil, Degas made great use of chalk as a painting medium. In his hands that light, crumbly material became veils of delicate, fragile dust iridescent with a thousand tones of chromatic variation. Pictures of ballet dancers, for example, become light as fluff as they float across our field of vision because of what Degas could do with chalks whether he used them alone or in combination with oil.

Today, when we look with informed eyes at the art of the Impressionists we realize how valuable was their gift of vision. As a group they changed the course and current of art. They dared to break the chains of sterile conformity to 19th century academic rules for painting. To see their work in the perspective of history is to recognize them as the greatest single liberating force at work setting art free during the Victorian era.

6 Edgar Degas *Ballerina and Lady with Fan* 1885, pastel, courtesy John G. Johnson collection, Philadelphia. The freshness of a moment out of the past, captured and preserved in chalk, feels as though it just took place, only an instant ago.

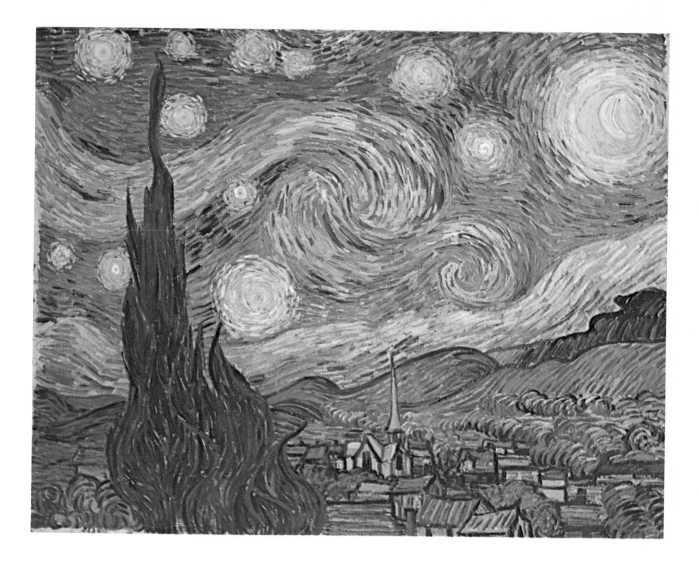

Vincent van Gogh *The Starry Night* 1889, oil on canvas; collection, The Museum of Modern Art, New York (acquired through the Lillie P. Bliss bequest).

2 | van Gogh—feelings are facts:
the reality of emotions made visible

The second half of the 19th century was a time when artists who broke with the academic tradition were faced with rebuff and ridicule. But, it was also a time eminently ready for exciting changes. The Impressionists, for example, managed to significantly advance the history of art with their new approaches to painting. Of course, they only went so far and then stopped short. The next steps forward had to be taken by others. Fortunately for the progress of painting there were artists who could and did take those next steps by starting where the Impressionists left off. Because they came right after the Impressionists and because they made use of the new world of color which the Impressionists had opened up they have come to be called the Post-Impressionists.

Of all the painters associated with *Post-Impressionism*, Vincent van Gogh is probably best known to most people. Unfortunately, his reputation is probably based upon the wrong reasons. Instead of knowing about him because of his considerable creative accomplishments, people think of him too frequently only in connection with the lurid reports of unusual and bizarre events that took place within the short and tragic span of his life. Not that the facts are inaccurate. After all, they are true. Furthermore, it is also true that his last years were overshadowed by seizures and states of irresponsibility which caused him to be hospitalized for periods of time. But, he was not a madman as is so often presumed. Rather, he was a profoundly sensitive person with a great gift for inventing shapes and colors that come alive as translations into paint of sensations and awarenesses experienced at the core of his being. Above all else, in van Gogh's work, feelings become facts. In their own way they are even more factual than the external appearance of people, places, and things.

Few artists have ever been able to match van Gogh in his uncanny knack for investing paint with such dimensions of humanized feeling. That is what the reality of his art is all about.

When efforts to become a picture dealer and evangelical missionary ended in failure van Gogh decided to become an artist. He pursued some formal studies in Brussels, Antwerp, and the Hague but virtually nothing came of them. For practical purposes, van Gogh was an artist who taught himself. On his own, he created a very individual language of vision. He brought that language into being because it was desperately important for him to do so.

7 Vincent van Gogh *The Starry Night* 1889, oil on canvas; collection, The Museum of Modern Art, New York (acquired through the Lillie P. Bliss bequest). Sensations of swirling movement contrast with the solidity of the ground below as the twisting forms of the cypress trees on the left reach like fingers for the sky. See color plate opposite page 16.

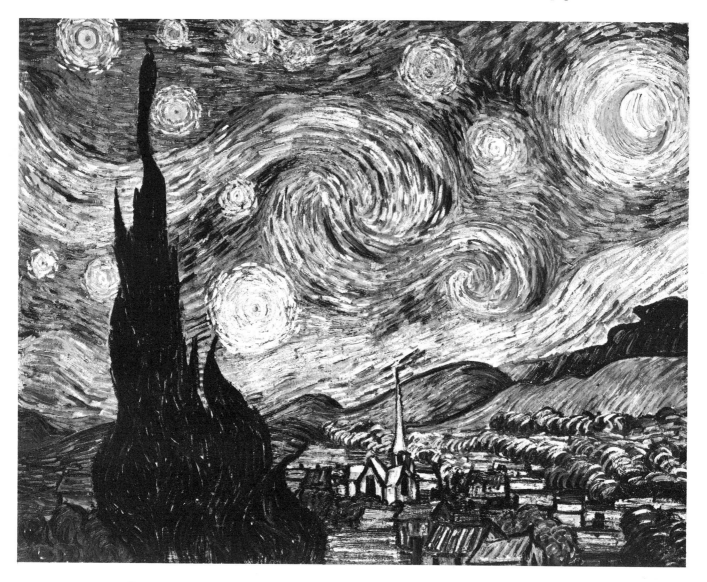

8 Vincent van Gogh *La Mousme* oil on canvas, National Gallery of Art, Washington, D.C. (Chester Dale collection). His interest in Japanese woodcut forms may have led van Gogh to use a Japanese word for the title of this picture; *mousme* means a young teenage girl.

Van Gogh's earliest pictures were extremely stiff, dark, and somber. A change took place when he came to Paris in 1886 to stay with his younger brother. Then and there, van Gogh discovered the work of the Impressionist painters. The impact of their painting was probably the most potent liberating force in his own creative development. Suddenly, his palette absorbed a taste for light and brilliance. Another important influence on the emergence of van Gogh's personal styles was his exposure to Japanese woodcuts. However, regardless of his debts to both *Impressionism* and Japanese prints his mature work was completely and uniquely his own.

When he moved to southern France in 1888 van Gogh's colors began to dazzle and vibrate beside each other as they never had before. In paintings from that period a magic radiance seems to glow from within the canvas just beneath his layers of paint. Individual strokes may be seen reflecting highlights and casting shadows of their own. In a very distinctive fashion the constellations of highlight and shadow formed by the rich paint build-up, became important elements in the compositions he completed during his last two years of life.

Regardless of the anguish he suffered and perhaps partly to gain respite from the constant torment he experienced within himself, van Gogh churned out a great wealth of work. He certainly wasted very little time in the short ten-year span he dedicated to art. During those years great changes are evident in his drawings and paintings. When comparisons are made between the early pieces and what came later it becomes obvious that he realized a lifetime of creative growth between 1880 and his death in 1890. The clumsiness of his earliest efforts came to be replaced with relatively lithe movements and darting gestures in paint. The pasty weight of his early pictures turned into trails of crisply articulated color. As you follow a cluster of strokes in a piece of work from the later period, your eyes are led through a daring tracery of movements that tie the composition together. You wonder how he did it. No matter how much you look you find it hard to believe that such grace and fluidity could be achieved with a material as thick and sluggish as oil paint.

But, technical brilliance in conceiving original approaches to design is not the whole story of van Gogh's skill as an artist. What makes

his work so very extraordinary is the way that his deeply personal imagery amplifies areas of feeling that are universal. You go to one of his pictures, look into what he has to show, and you find yourself saying, "Yes, that is right. What I see here rings true. He confirms my own sensations or else he sensitizes me to new levels of awareness I might otherwise have missed."

Other artists have used the same paints as van Gogh—but, they have not been able to match his accomplishments. Apparently, there is much more to his art than the paint and canvas materials which seem to be all there is. What can it be? Perhaps it is a strange, mystical, emotional electricity which somehow defies either measurement or adequate description in words. It can only be experienced in direct contact with examples of his work. It has never been successfully explained.

Far from being unable to control himself van Gogh managed to paint with consummate care. It is obvious from even a cursory examination of his work that he placed his pigments on canvas with precision and acumen. If van Gogh had tossed paint about in a fit of frenzy the clarity of color and individually placed strokes would not be as they are. Slurring oils madly about upon a surface results only in splotches of muddy color. Surely, some of his paintings were done with great speed, but others took time—sometimes, a great deal of time. In letters to his brother, van Gogh wrote at length about the compositional problems he sought to resolve by thorough, careful thought as much as depth of feeling. In all of his mature work subject matter became a pattern of shapes and colors. Twisting forces were balanced by counter movements. For every rush forward there is a braking action. No single part of any picture ever runs away with itself. The composition as a whole always informs the parts and gives them their meaning—visually. As van Gogh explained in his letters, working things out—like deciding just which green or yellow to use—had to take time, thought, and judgment in order that everything in a given design would come to feel right.

Unfortunately, van Gogh was unable to cope with life. The feelings of tension, uncertainty, and rejection became too much for him to bear. Eventually, even the relief from internal suffering that painting helped alleviate was inadequate to his needs. Perhaps, even painting imposed burdens too oppressive to be borne any further. In desperation, van Gogh destroyed himself with a pistol in 1890 at the age of thirty-seven.

During his lifetime, van Gogh never achieved critical acclaim. He could hardly even get his work placed on exhibition, let alone have it

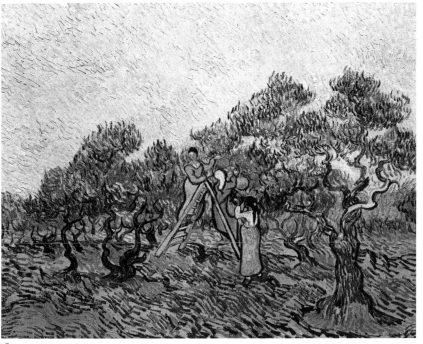

9

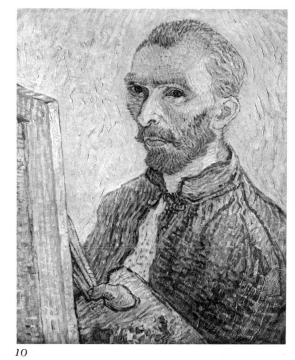

10

9 Vincent van Gogh *The Olive Orchard* oil on canvas, National Gallery of Art, Washington, D.C. (Chester Dale collection). A quiet composition, bathed in bright light, tingles with motion as the heavy flecks of paint lead our vision across every inch of the composition.

10 Vincent van Gogh *Self-Portrait* oil on canvas, National Gallery of Art, Washington, D.C. (Chester Dale collection). The more we study this picture, the more we become aware of van Gogh's powerful, personal feelings rising up from the paints to make contact with our own inner feelings.

looked at by interested people. Evidently many people in the latter part of the 19th century were simply not ready for him or his art. An appreciative audience for his efforts did not appear until the 20th century. Artists especially have learned endless lessons from him. While he was a very poor art student in the academic sense, his pictures have opened the eyes and exercised the hearts and minds of countless artists who have followed him. His art has taught them to feel deeply—down to the very marrow of their bones and to think with every fibre of nerve tissue at their command. But, most of all, he has shown artists the way to follow if they would be true to their convictions. He has provided an example of how one should not compromise personal integrity in the face of hostility or stupid rebuff from a public that will not or cannot take the trouble to dislodge preconceived prejudices and seek to meet the artist with something new to say on his own terms.

3 | Gauguin—from the outer edges of the art world

During the 19th century, Paris, the capital of France, might just as well have been the center of the universe as far as art was concerned. There were good reasons why. The annual salon exhibitions held there, for example, established the models for what was fashionable in any given year. Then, too, most of the seriously read art critics were employed as reviewers by the Parisian press. In addition, Paris was the major marketplace of the art world. Consequently, many talented artists from abroad came there since they were more likely to succeed commercially in Paris than elsewhere. Finally, the city provided artists with an atmosphere and milieu that were curiously conducive to exceptionally high levels of creative production. All of these factors help to explain why artists of such diverse expressional outlook as the academicians and the Impressionists were both able to pursue their opposite aims in Paris and also attract support from people interested in art. Nevertheless, in spite of these several reasons, Paris was not a comfortable place for every single artist of the 19th century. Paul Gauguin, for example, felt ill at ease there. To find his potentials and fulfill them he had to live and work way out beyond the fringes of the conventional art community in Paris.

Like van Gogh, Gauguin was a typically romantic figure. His biography vividly reflects the stereotype of a dreamer dedicated to the pursuit of deeply personal ideals too impossible to realize in the everyday world of practical realities. The itchy and often colorful details of Gauguin's restless and turbulent days have been dramatized in fictional versions for popular consumption in print and upon the screen. Unfortunately, such sensational treatments generally fail to show the esthetic and expressional significance of his paintings.

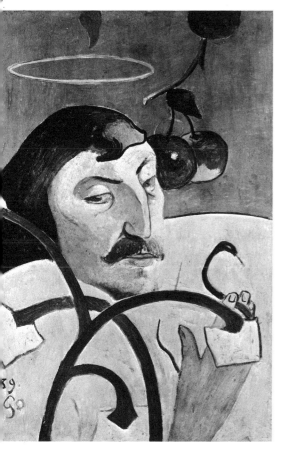

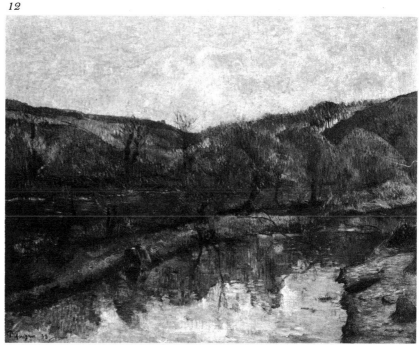

11 Paul Gauguin *Self-Portrait* 1889, oil on wood, National Gallery of Art, Washington, D.C. (Chester Dale collection). With wry humor, Gauguin pictured himself, under an angel's halo, holding a serpent while two apples (from Eden?) are suspended on a branch behind his head.

12 Paul Gauguin *Brittany Landscape* oil on canvas, National Gallery of Art, Washington, D.C. (Chester Dale collection). Gauguin left Paris and went to live and paint in Brittany (pictured here) in order to break free from the routine life he had led in the city.

Gauguin had achieved quite a success as a stockbroker when he decided to abandon his career in finance. At the age of 36, he left his life as a businessman behind him, virtually cut himself off from his family, and became a painter. Traveling with very little money Gauguin went to Pont-Aven in Brittany to get away from the routine life he had known in the city. He wanted to be free of his past. Apparently, he felt that the best way to break free was to separate himself from everything that had been familiar to him. From Brittany he went to Martinique and then to Panama. Eventually, he returned to Paris but he found the city as intolerable as it had been when he left the first time.

In 1891 Gauguin went to live in the South Seas. Returning to Paris only one more time, he came to feel that Western civilization

epitomized by the life of the city, would only strangle the noble savage inside of him. He found the city so repulsive that he decided to spend the rest of his life in the islands. From letters and from his journal we learn that Gauguin was attracted to Tahiti because he felt that it provided a necessary escape from the evils of an industrialized society as well as an opportunity to renew his weary spirit. Furthermore, he presumed that life there would be free of financial difficulties while he would be able to find subject matter appropriately suited to his needs for personal expression. Unfortunately, as time passed on, his life ebbed away in the tropics. To the end, he paid for his freedom from civilization with internal bitterness born of repeated disappointments, resentment, and frustration. To make the pangs even more painful, he suffered agonizing physical hardships from economic privation and deeply debilitating diseases. In spite of it all, in his art, he was able to transcend the misery and horror that were his lot during those dreadful days.

In his work from the South Seas we readily see that Gauguin turned away from literal representation in his quest for profound states of tranquility and nobility of the spirit. Playing the part of conjurer and poet he made paint breathe and glow with a special brand of magic all its own.

Color was the soul of Gauguin's art. As a Post-Impressionist he employed a wide range of hues—some loud and bright—others soft and restful. After he would select a spectrum of paints suitable to a given composition he would apply them in broad, flat areas with little, if any, use of modeling to suggest roundness or three dimensionality. His pictures are like flat planes of colored canvas rather than windows through which to view nature. The forms of trees, foliage, or people are submerged within rich tapestries of shape and pattern. The movements within the forms, as they are identified in different colors, are at the center of his work. Each spot and dot is tied to whatever is beside it or around it. They are all connected. Nothing is left to go astray. Perhaps that is why Gauguin's sense of design provides us with such deep reservoirs of art experience. We may return to them again and again. We never exhaust all that he has to show us if we will but look and look and look.

Gauguin's brush was like a voice of protest exclaiming dissatisfaction with the fashionable Western art of the late 19th century. His pictures from the Pacific reveal a way of life entirely opposite and apart from the European society of that period. While the animal or human figures in his paintings may feel flat rather than round they still project considerable expressive power. Yet, they also appear gentle. Above all, they feel natural in their settings as

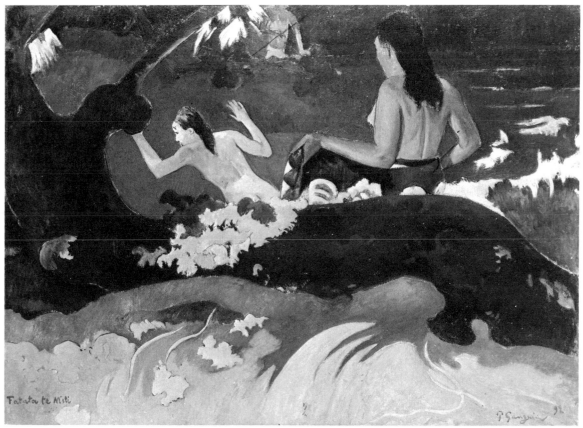

13

13 Paul Gauguin *Fatata Te Miti* 1892, oil on canvas, National Gallery of Art, Washington, D.C. (Chester Dale collection). Polynesian figures occupy a lush tropical paradise in this lively tapestry of design from Gauguin's work in the islands of the Pacific.

14 Paul Gauguin *Maruru* c.1894, woodcut, collection, Philadelphia Museum of Art (photograph by A. J. Wyatt, staff photographer). Primitive feelings were joined with a sophisticated treatment by Gauguin when he created this bold image that is delicately laced with a tracery of sensitive, light areas.

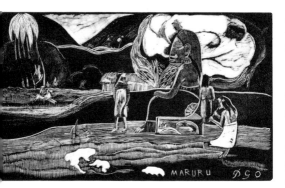

they reflect quiet peacefulness, dignity, earthiness, and unspoiled simplicity.

During his lifetime, Gauguin attracted a small coterie of admiring followers who called themselves the *Nabis*. However, Gauguin had no use for such a role and he took care to avoid the group. Eventually, two important art movements became heirs to his vision. They were *Expressionism* in Germany, and *Fauvism* in France. Gauguin's influence on their emergence and development cannot be adequately described in words or measured with numbers. However, to this very day, both artists and the general public continue to be nourished and stimulated by his work.

4 | Seurat—the projection of an idealized reality

Painting within the limits of a precise formula presents grave risks to a young artist. In no time at all he may be grinding out tiresome variations of his own clichés. As a rule, artists evolve a style of their own very gradually. Little by little, the combination of accumulated experiences and personal evaluations leads to the creation of a highly individual language of expression. In contrast to that convention, Georges Seurat formulated his special brand of form very early in his career. He then adhered to it just as tightly as he possibly could. By all precedent he should have been sterile, confined, and empty. Instead, we find the very opposite. His paintings sparkle with painterly vitality and surprise us with their inventive wit. We are even inclined to think that Seurat would have gone further and done much more with his special method if he had not died abruptly, of high fever from a blood infection, at the age of thirty-two.

Seurat came along at a time when *Impressionism* was in need of help. By the middle of the 1880's the once revolutionary movement had begun to grow stale. The idea of capturing the essence of an instantaneous moment was wearing thin. The painters associated with the Impressionist approach were turning out picture after picture as wispy as fluff. Unlike the explorations of a decade earlier the later works were, so to speak, beginning to fall apart within the paint. Compositional solidity and profound insight based upon careful, thoughtful reflection began to fade from view. This tendency toward wishy-washy weakness in the most avant-garde painting movement of that time disturbed Seurat and he set out to do what he could do to put things right. In his own way, he did. In effect, he built a *Neo-Impressionism* or new Impressionism.

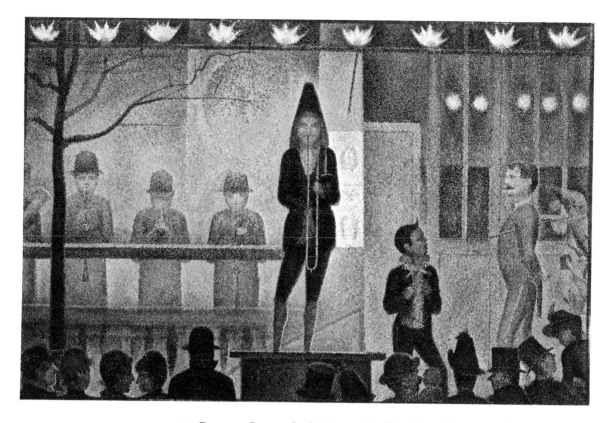

15 Georges Seurat *Invitation to the Side Show* (*La Parade*) oil on canvas, The Metropolitan Museum of Art (bequest of Stephen C. Clark, 1960). The sense of order is awesome and monumental.

Seurat developed a systematic approach to painting. His technique has come to be called *Divisionism* because it was based upon the divisions of color established by the scientist, Chevreul. Because he painted in a uniform stipple stroke, his technique is also called *Pointilism* (paint applied with the tip or *point* of the brush).

Prior to starting work on a painting Seurat devoted patient and careful thought to the project. He would spend lots and lots of time in profound contemplation. That may help to explain why his orchestrations of form reflect no sudden impulsiveness. Some artists might have become crushed by such iron discipline. Seurat was not.

Before he got into a major work, Seurat would explore the ramifications and contingencies that lay before him. Limitations as well as potentialities were explored in depth through drawings and color studies. Such analysis allowed Seurat to come to grips with important problems while a painting was still in the germinating stage. As a result of his preliminary efforts he was thus relatively free to con-

centrate on the application of paint to canvas with such grace when he got to the full-size, final version of a painting idea.

The sense of order in a picture by Seurat is no slight matter. It is monumental. And, of course, it was not arrived at by accident. Rather than reflect a fleeting glimpse of how something appeared in a flickering moment Seurat *transformed* his perceptions. He refined the raw sensations of visual experience and converted them into timeless abstractions. In other words, when we look into his work we see generalities in form rather than particular objects.

As we examine paintings by Seurat our capacities for visual response become thoroughly exercised. We find ourselves enmeshed in his language of vision. Clearly, he was not hung up with descriptive illustration. Obviously, Seurat has left that to the photographer. His compositions could never be made with the cold glass eye of a camera lens. Instead, his art is human and deeply personal even though it is not feverish and molten as is so often the case with an

16 Georges Seurat *Port-En-Bessin, Entrance to the Harbor* 1888, oil on canvas, collection, The Museum of Modern Art, New York (Lillie B. Bliss collection). Seen first as a pattern of flat shapes, the composition opens up a deep sense of space upon continued examination.

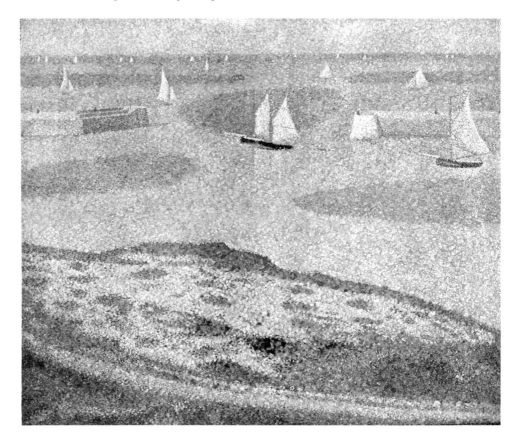

artist like van Gogh. Where intense feeling is the ultimate reality of a van Gogh picture, concentrated thought passionately dedicated to the pursuit of perfection is the ultimate reality of a painting by Seurat. His work projects an image of the world as it possibly ought to be—free of chaos and filled with serenity.

The use of color was the crowning achievement of Seurat's art. First, his colors were mixed on a palette. Then he would apply the paints in regular, repeated dot-like strokes. One might fully expect such strokes to be dull and monotonous. As it turns out, they never become tiresome. Because Seurat painted in *variations* of color the dotted areas of paint come alive in contrasts and harmonies of hue, intensity, and value. Areas of color glow with light because no color ever appears alone anywhere in a composition. For example, take a patch of grass rendered in greens within a picture. Into the field of grass you may find that Seurat has scattered little specks of red-orange like a very light dusting of pepper into a pot of soup. The little touches of complementary color bring out the full, rich flavor of the greens. You look again and you see still more. Little hints of cool violet play up the warm yellow components of the green pigment. Even delicate suggestions of little blue dots may be seen as they release the fullest potentials of the orange-red notes that were introduced to make the greens function at their maximum possible power. As you move, from area to area you find that Seurat has applied his paints so methodically that your retina is constantly bombarded and then soothed by the most masterful kind of chromatic counterplay. It is as though Seurat has made a light organ of his palette. Your eyes become visual ears as they tingle to the tune that builds and builds in a picture before you while Seurat seems to keep on pulling out the stops without end. The longer you can pay attention to the canvas the more you will find area after area of color sensations that are unlike anything else in this world.

Even though the interactions of color in a Seurat painting are a gratifying source of visual experience, they are not all there is to his work. Instead, they are part of a larger totality—the *whole* composition of any given picture. The composition is the sum of all the visual elements and the relationships between the elements. The composition includes the color, of course—but also, the shapes, the patterns, the space, and the way they are all woven together in a

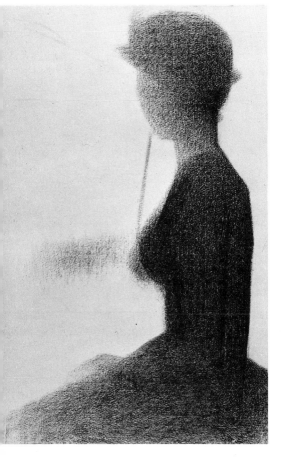

17 Georges Seurat *Seated Woman* c.1885, crayon, collection, The Museum of Modern Art, New York. Work on preliminary studies like this example helped Seurat refine the precision he brought to his finished work in oil on canvas.

particular piece of work. The pictures are so elegantly partitioned. The proportions between the shapes must be looked at with prolonged contemplation. You have to see how areas line up and then cut apart from each other. The subtle counterpoints between horizontal, vertical, diagonal, and curved elements need to be carefully studied lest they be missed. A painting by Seurat should be looked at first as a configuration on a flat surface. Then,—slowly, it must be allowed to open up. Step by step, you move into the depth of the picture and tread your way from one overlapping shape to the next as far as you can go and then you come back out and find yourself somewhere else other than where you started.

When you can, you should go back to a Seurat painting you have formerly seen. You may well find new paths of vision you missed the first time around. It is a little like rereading a good book. It is not possible to take it all in within the space of one contact. Likewise, the more you return to the painting, the more you will find in it. Perhaps that is one of the classic tests of any significant work of art. Trivia may be completely drained with one exposure. Genuinely qualitative art is neither quickly nor easily divested of itself.

5 | Cézanne—from perception toward design

Probably no 19th century painter has been as much admired and studied by 20th century artists as Paul Cézanne. Sadly though, during his own lifetime no artist suffered more from misunderstanding and attacks upon his work. He had a will made of steel. How else could he have withstood the abuse leveled against him through the long and trying years he spent carving out a sense of monumentality in form?

In the market place, where popular success is regularly measured, Cézanne was virtually a complete failure. Likewise, in the Salon exhibitions of the 19th century, Cézanne was also a failure. The work he sent for consideration by the juries was (with one rare exception) rejected year after year. The public of his day found Cézanne's pictures clumsy, awkward, and utterly strange. Eyes that were educated to see and value academic art simply did not know what to make of his style. It was unfamiliar and it seemed to be all wrong. In a way, they were right. As far as fashionable 19th century academic practice was concerned, Cézanne's pictures *were* all wrong. (Of course, that doesn't really say much for fashionable 19th century academic practice.)

For Cézanne, thinking was pictorial. He felt the spirit that dwelt in the space between the things of nature and the forms to be distilled from them. He believed that only in nature could an artist exercise all of his potentials for perception. Painting was an instrument for bringing such perceptions to final realization. Through his art he was able to close the gap between nature and esthetic form. The paintings of his mature period delicately touch the exact point of balance between abstract patterns in paint and the appearance of nature visible to our eyes. With an uncanny knack that defies de-

scription Cézanne viewed nature as though he were looking through a transparent glass window and a silvered pane that reflected his own creative imagination at the very same time.

From the outset, when Cézanne came to Paris to study, he found the slick and picturesque formulas of academic painting entirely out of tune with his temperament. He became absorbed by the development of *Impressionism*. But, before long he found that for him the methods of *Impressionism* also had grave shortcomings. For example, because of their typical emphasis on the transitory appearance of objects, Impressionist pictures often tend to be vaporous visions in paint. By contrast, Cézanne wanted to create a sense of substance and solidity which would be akin to the art of the old masters whom he studied in the museums. Of course, he did not mean to merely mimic the accomplishments of the past. Instead, he wanted to create the art of painting anew. His problem was centered upon building a sense of order in form. He did not want to simply imitate the superficial appearance of order one may presume to see in nature. He wanted to structure a body of expressive form with an identity and integrity of its own in paint on canvas.

18 Paul Cézanne *Mont Sainte Victoire* 1904-1906, oil on canvas, Philadelphia Museum of Art, George W. Elkins collection (photograph by A. J. Wyatt, staff photographer). Cézanne sought to achieve the solidity of the old masters with the forms and colors he inherited from the Impressionists.

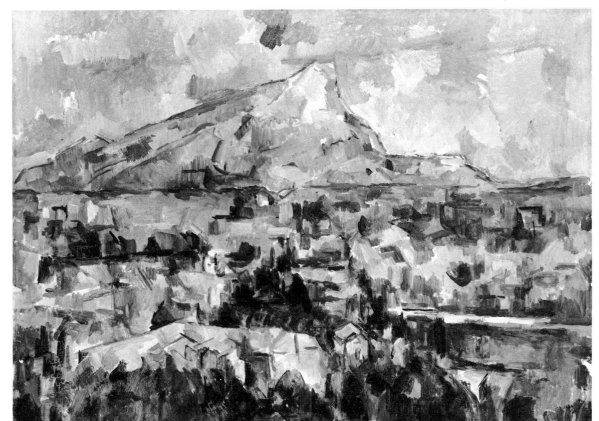

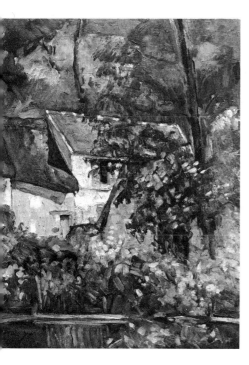

19 Paul Cézanne *House of Père la Croix* 1873, oil on canvas, National Gallery of Art, Washington, D.C. (Chester Dale collection). Little spots of color, added to each other, become increasingly larger shapes that are firmly knit together within the over-all composition.

In effect, Cézanne asked himself, "How can I honestly and truthfully bring my experience with a three-dimensional world into being on a flat, two-dimensional surface without compromising the integrity of the actual perception on the one hand or the integrity of the flat canvas on the other?" For Cézanne it was a serious dilemma and he struggled with it continuously throughout his long life as a painter.

Spatially, the world that surrounds all of us is a three-dimensional reality. The fact is so self-evident we usually take it for granted. In comparison with the surrounding world, the surface of a stretched canvas exists physically in only two dimensions. Clearly then, paints spread on such surfaces have a real existence in only two dimensions. Yet, simultaneously, they are also part of the larger, over-all three-dimensional world. A painting can therefore be an awfully complicated affair so far as the realities within it are concerned. Cézanne was deeply involved with the question of what is true in art and what is true in the world at large. As an artist he sought to find means for reconciling the differences between them. The heart of the problem was the fact that a picture on a two-dimensional surface that tries to "look" three-dimensional must inevitably distort the *truth* of that flat surface. Likewise, the image that *appears* three-dimensional (on a surface that is actually two-dimensional) is never really the same as what we genuinely see when we look out on the world around us.

Cézanne found that first he needed to examine how seeing takes place in order to cultivate his inner resources for visual perception. When you stop to think about it you come to realize that *seeing* is a terribly complex activity. As we use our eyes we are busily digesting hundreds of reports. They are the vast minutiae of optical stimuli that bombard our sense of sight. We synthesize those many fragments into a whole which we can accommodate or accept. We also tune out what is irrelevant to us and tune up what we do want to see. All of this goes on within continuous twinklings of our eye. And, all the time, we involve both subconscious as well as conscious awareness in the total process. Cézanne set himself the task of developing the process of putting his senses to work and then arranging the feedback with the most advanced measure of refinement he could attain. What patience he exercised. He would take time to study

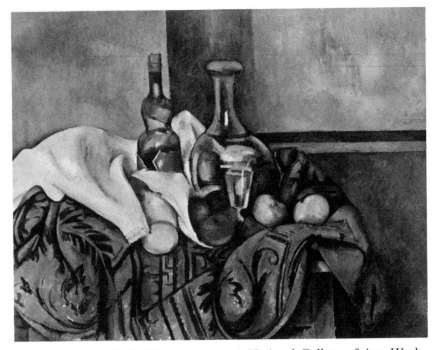

20 Paul Cézanne *Still Life* oil on canvas, National Gallery of Art, Washington, D.C. (Chester Dale collection). Even a still life subject presents the stability and fullness of a mountain in this painting by Cézanne.

a given complex of subject matter elements. Some subjects grew tired of sitting for him. Fruits in a still life would begin to deteriorate long before he was done examining them. He made intense efforts to filter out everything that was extraneous. What he retained was the vital center—the solid core—of his perceptions.

His next problem consisted of deciding how to best translate the essence of his refined perceptions of the three-dimensional world into paints applied upon a two-dimensional surface. He solved the problem by inventing a new way of painting. Traditional efforts to represent objects in space by imitating their colors and modeling their forms with black for shade and white for light were abandoned because they violated Cézanne's notion of the true nature of paints and flat, stretched canvas. Instead, Cézanne used little flat strokes of pure color to *build up* his pictures. Each separate little stroke was flat—as flat as the two-dimensional surface of his canvas. The form of the picture took shape as a result of one flat stroke of color being added to another flat stroke of color and so on until thousands of such single strokes became the total composite design of the painting. In a way that must be seen to be appreciated and understood, a whole new kind of picture concept emerged. Stated briefly—the *creative* role of the painter became increasingly more significant as

the imitative function, or role of the artist as a camera, became less important. Perhaps the very fact that the camera had been invented and improved to the point of practical efficiency in the 19th century helped pave the way for Cézanne to achieve the breakthrough that he did.

Because the design structure of his paintings became more meaningful to him than the mere rendering of subject matter, Cézanne was prepared to exercise poetic license in making his pictures. For example, a dish in the world outside the canvas might have had a certain shape as Cézanne looked at it. However, particular elements in a composition he was working on may have required that the shape of the dish be modified (or, as some like to say, distorted) in order that it work effectively within the design inside the world of the canvas. In such an instance Cézanne readily bent the subject matter to the needs of the painting and modified (or distorted) the shape of the dish rather than throw the design of the work out of order by illustrating the dish mechanically in an academically correct manner.

As the transition from perception toward design became important, Cézanne also sought to tie surface and depth to each other in his

21 Paul Cézanne *The Card Players* oil on canvas, The Metropolitan Museum of Art (bequest of Stephen C. Clark, 1960). From his careful observation of figures in a setting Cézanne has taken repeating round shapes and straight lines and turned them into elements of a design that is strangely silent and yet, sweepingly alive.

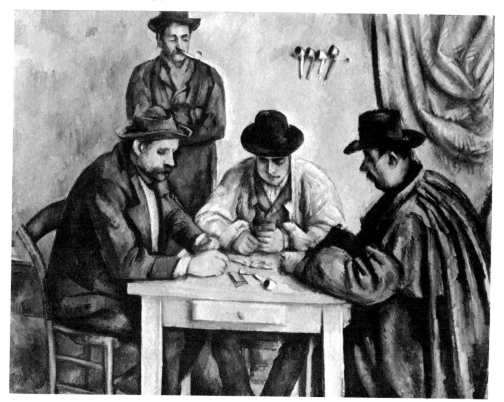

paintings. In his best work you find that foreground, middle-ground, and background merge together. The space in his pictures becomes a fused, crystallized unity within which the shapes and colors of the design work together for all they are worth.

Because Cézanne felt that the techniques of the Impressionists led to pictures that were hazy, loose, and foggy he tried to find ways of achieving solidity in his work. In his early work he loaded his canvases with heavy impastos or thick layers of oil paint to bring out a given subject. In time it became clear to him that bulk in the medium did not automatically insure solidity in a picture. Gradually, he came to see that a sense of solidity could be built with colors in a painting. As he learned to use more fluid color in his brushes the paints on his canvases lost their lumpy, lathered look and then became more truly two-dimensional, thus honoring the truth of the surface.

Perhaps what is most fascinating about Cézanne's art is the sense of paradox inherent in it. The more he identified the two dimensionality of his canvas the more he managed to open up feelings of volume because the elements of design he composed in paint became planes of color that advance and recede spatially in his compositions. Where he painted in thin, flat little strokes of color—one upon another or one beside another—compositional orchestrations emerged that are rich, solid, and monumental in feeling. Clearly, such qualities are the exact opposite of what might be expected from the use of short, choppy strokes of paint. As he sought to transform three-dimensional perceptions into two-dimensional designs he was able to penetrate beyond the surfaces of his subject matter. So often, you feel that you are seeing into his subject matter and even through the subject matter. And yet, his thin veils of vision become massive and overwhelming in their impact upon our sensibilities. Of course, these contradictions exist only on a verbal level. In the paint itself there is no paradox. Rather, there is a unity. The parts hold together beautifully in compositions that speak out with convincing conviction and firm resolution.

6 | Matisse—patterns of paint buzzing with life

The significant creative art of the 20th century got underway with an explosion of sorts. It all began when Louis Vauxcelles, an art critic for a French newspaper, wrote about a group of paintings shown at the Autumn Salon of Paris in the year 1905. The effects of that exhibition and Vauxcelles' article have continued to be felt, thought about, and discussed to the present day.

Reviewing the efforts of several young painters he saw in one room at the exhibition, Vauxcelles referred to their paintings as the work of wild beasts or, to use the exact French word, *Fauves*. The word caught on. Somehow, the popular fancy was ignited. In almost no time at all, fashionably sophisticated people were having a fine time for themselves laughing at the art of the *wild beasts* or *Fauvism* as the new movement came to be called. Especially singled out for ridicule was Henri Matisse. Perhaps because he was a bit older than the others and because he was looked up to as a leader, his work bore much of the burden from the critical attacks aimed at the whole group.

What was it about *Fauvism* that aroused the prim and proper citizenry who lived in the aftermath of the Victorian era around the turn of the century? Maybe it was the jolt of high-keyed colors used by the artists. Not even van Gogh and Gauguin had employed amounts of color in such juxtapositions of blue, orange, yellow, pink, green and violet as the Fauves. Furthermore, the paint was applied with vigor and gusto. Even now, as we look at their work, we can still feel the snap of a brush tipped with pure pigment slapping against the reverberating threads of linen canvas. The surfaces of multicolored paint tingle vibrantly inside of us as we get in touch with the forms that face us. How much more of a visual shock it

must have been for people with eyes unaccustomed as we are to neon light and technicolor movies!

Beyond his unfamiliarity with lively color, the gallery visitor in 1905 must have felt twinges of astonishment as he confronted such vigorous emotional expressions. Think back to that day and age. It was a time when feelings were supposed to be kept locked up under wraps deep within oneself. Consider then what it might have been like to suddenly see brilliant colors asserting an artist's excitement about the intensity of his involvement with his creative work. Even today, more than anything else, our feelings are raised to a pitch of high tension as we get into the sweeping, grinding, churning action of the Fauvist forms. They swirl into each other within the network of our nervous systems. The action mounts as we stay

22 Henri Matisse *The Moorish Screen* 1922, oil on canvas, collection, Philadelphia Museum of Art, bequest of Lisa Norris Elkins (photograph by A. J. Wyatt, staff photographer). The details of the room interior twist and turn with vitality as they surround the figures and join with them to become a soundly unified composition.

23 Henri Matisse *Still Life: Apples on Pink Tablecloth* oil on canvas, National Gallery of Art, Washington, D.C. (Chester Dale collection). Picking up where the Post Impressionists had stopped, Matisse sought to move the craft of painting forward. See color plate opposite page 49.

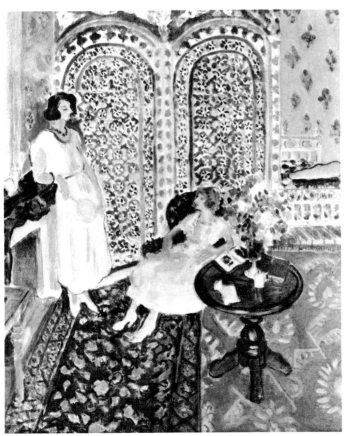

22

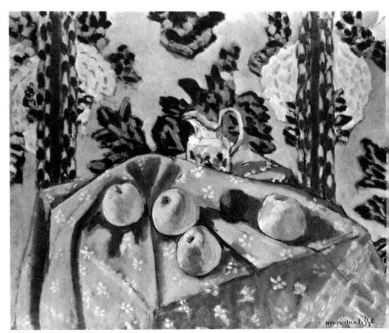

23

with a given piece of work. The more we look the more it turns us on. We feel patches of paint vibrating beside each other—strokes of pigment unleashing electric currents that buzz with life as we follow them back and forth across the surface of a composition.

Picking up where van Gogh and Gauguin had left off the Fauve painters sought to move their craft forward. It mattered little to them that critics and public alike found their work hard to take. Somehow, they believed there would eventually be people willing to look at their pictures without malice and prejudice. As artists committed to the pursuit of integrity in their work, they knew they could not permit themselves to become too concerned about those who could not or would not meet their efforts halfway. Genuinely creative artists cannot afford the luxury of taking time out to think about approval from the public. If they do, they run the risk of losing sight of their central concern: to create expressive forms filled with power and strength. The work of the Fauves illustrates this notion so well. Certainly, their work was strong and powerful —and it still is.

As a formal school of thought *Fauvism* did not last long. Only a few years after the furor that came from their showing together died down the various artists (such as Dufy, Derain, Vlaminck, and Rouault) went their own separate ways. Matisse, whose thinking had been the dominating influence on the group, went on to grow and develop in ever expanding dimensions of creative achievement and leadership.

Most of his pictures place us in a mood and spirit of springtime regardless of what the season is outside. The forms are bright and a light breeze blows through the scene. We feel a closeness to nature as the rhythms of life pulse through his compositions. It all looks so easy. The very hard work that went into making his art is hard to find. None of his labors are left for us to share. Instead, he has provided us with the triumph that comes *after* the struggle of creative effort has been completed.

Matisse was frequently accused of making pictures like a child. In response to such accusations, he used to explain that that was exactly what he was up to. He was trying to recapture the freshness of vision characteristic of the young child when all the world is new to him. Think of how the bright light of the morning sun excites a child. He can remember that the last time he looked outside (the night before) a blanket of darkness had covered over the world. The child marvels at the miracle of the change. The vision of most adults is so jaded. They have forgotten how to experience awe and excitement over what they can see. To look into the art of

Matisse is to rediscover a way of seeing the world clearly, intensely, and vividly.

While the art of Matisse may in some respects be *child-like* it is never childish. As an adult, Matisse had to break free of his academic training. Verbally, that might sound very easy. In actual fact, asserting one's freedom from adult-conditioned modes of vision is extremely difficult. Furthermore, it is a problem the young child need not and cannot contend with simply because he *is* young.

The artist who tries to recapture the freshness of a child-like eye must drive himself to reassert his esthetic impulsiveness. By contrast, the child is impulsive naturally. He has not yet learned to curb and completely control his impulsiveness. The adult artist is caught between the desire to exercise impulse and the need to exert control. In short, the mature artist who seeks to see again like a child must cultivate a very sophisticated vision. It is not enough for him to merely select colors and apply paint. Because he is an adult—with adult demands and needs to fulfill—he must know, at least for himself, *why* he selects certain colors and how they interact

24 Henri Matisse *Les Gorges du Loup* oil on canvas, National Gallery of Art, Washington, D.C. (Chester Dale collection). As the trees spread their foliage, a spirit of springtime illuminates the scene.

25 Henri Matisse *The Plumed Hat* oil on canvas, National Gallery of Art, Washington, D.C. (Chester Dale collection). Freshness and directness are immediately evident as we get closer and closer to the forms that face us here.

with each other compositionally. As a consequence, the childlike art of Matisse has an emotional and intellectual depth that childish art almost never has. For example, a child's picture may have a certain refreshingly rugged crudeness about it. The crudeness may come from the child's relative lack of muscular coordination and fine finger control. The "crudeness" in the work of an adult is something else. More often than not, the "crudeness" of the adult artist comes from his need to make forms that are free from the smooth slickness of bland academic art.

The ultimate reality of a Matisse painting is the intensity of his perception. He would examine a subject with such profound care. Studies would be made. Over and over again he would draw, and draw, and draw. His aim was the unveiling of the essence of his subject matter. Like Gauguin, van Gogh, Cézanne, and Seurat before him, he sought to strip away the outer appearance of people, places, and things. When he got to the heart of his subject he would then shape it into a whole new vision in paint on a flat surface. What may look absurdly *simple* in the final outcome was actually arrived at by slow, complex processes of *simplification*—which is not at all the same thing as being *simple*. But, as it always must be with painting, you have to see actual paintings rather than merely read about them in order to know what they are about and how they work. Only then, may the full meaning of simplification (with all of its mystery and complexity) become completely clear and meaningful.

7 Expressionism—a new focus on the drama of life

Most of our thoughts and deeds are the outcome of interactions with other people. Art movements, which are extensions of people, also interact with each other. Furthermore, art movements can travel across the borders that separate one country from another. For example, the movement known as *Expressionism* was largely centered in Germany. But, several of the important influences prompting the emergence of *Expressionism* came from afar. Specifically, they included the art of van Gogh from France, the pictures by Gauguin from the Pacific, and primitive Oceanic art which could be seen in the ethnological section of the city museum in Dresden during the early years of the 20th century.

The word *Expressionism* (with a capital *E*) needs some explanation. Obviously, all art is concerned with the expression of ideas and feelings in a language of form. Therefore, all art is expressional. As such, the artists who comprised the Expressionist movement were concerned with expressing themselves in paint on canvas. What distinguished their expression from any other group of artists, was their emphasis on making vigorous subjective responses to life that were embodied in deeply personal, highly inventive visual metaphors. As a rule, their efforts reflect a rapid-fire, direct, aggressively muscular approach to brush and media—so very much the opposite of how the Impressionists went about painting their pictures. Also, unlike the Impressionists, the Expressionists were chiefly concerned with the psychological and social drama of life. For that reason, subject matter which plays a most significant role in their work was selected with great care and considerable thought before the painting act ever got underway.

At roughly the same time that *Fauvism* appeared in France, several

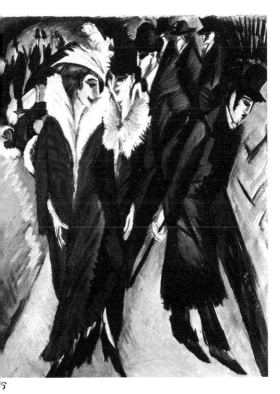

26 Ernst Ludwig Kirchner *The Street* 1913, oil on canvas, collection, The Museum of Modern Art, New York. Harsh angularities and slashing strokes of color express the tension and emptiness of life Kirchner found in a big city in pre-World War I Germany.

young men in Germany joined together as a group called *Die Brücke* (The Bridge). They included Erich Heckel, Karl Schmidt-Rottluff, and Ernst Ludwig Kirchner. Their great common interest was painting. However, because they happened to initially be students of architecture rather than painting, they were able to develop a new vision of their own with relative freedom. Living closely together in the city of Dresden they influenced and reinforced each other's ideas. Possibly that explains why their combined efforts took on a strength no one of them would have been likely to achieve on his own.

They used the name *Die Brücke* (The Bridge) to suggest an access or path away from esthetic conventions of the past. It was their hope that such a path would point a forward-looking direction into the future and that all the revolutionary tendencies then bubbling in the art world would be borne along by the thrust of their forward motion.

In addition to the sources already mentioned another prominent influence upon the development of Expressionism was the work of Edvard Munch, a Norwegian artist who visited in Germany. Typically, Munch's pictures are filled with a sense of anguish. Hypersensitive and gloomy as a result of emotional misfortunes in his own life, Munch had a remarkable talent for illuminating the tragic side of human experience in his art. Investing his canvases with great visual power his forms convey a sense of brooding, despair, and loneliness. Certainly such sensations have been felt by all people at some time in their lives. That probably explains why his work has a ring of truth that resonates poignantly throughout his shapes and colors.

As Expressionism grew in influence the members of the original *Brücke* group were joined by Emil Nolde, Max Pechstein, Cuno Amiet, and Otto Muller. In addition, a number of independent artists such as Christian Rohlfs and Paula Modersohn-Becker appeared in Germany, each working out a personal style of painting that had much in common with the efforts of the *Brücke* movement.

The actual *Brücke* group disbanded by 1913. However, all of the artists who were originally associated with the movement continued

27 Edvard Munch *Anxiety* 1896, Multicolor lithograph, collection, The Museum of Modern Art, New York. Feelings of uncertainty and personal alienation are generated with profound poignancy by the forms in the work.

to develop along the lines they had established when they first worked together.

A second phase of *Expressionism* got underway in 1911 with the creation of a group called: *Der Blaue Reiter* (The Blue Rider). The name was coined by the painters Wassily Kandinsky and Franz Marc who wished to have a distinctive term of reference for their particular direction in the over-all development of the Expressionist movement. As Kandinsky explained it: they both liked the color blue, Marc using it for pictures of horses and Kandinsky for riders in some of his paintings. In addition to Kandinsky and Marc there were also many other participants in the exhibitions sponsored by their group. In particular, Paul Klee, Auguste Macke, and Alexei Jawlensky earned especially widespread reputations.

The *Blaue Reiter* was chiefly centered in the city of Munich. Their main purpose was to unite there and exhibit the work of young, creative artists. Above all else they were concerned with paintings that had something fresh to say—something off the beaten path of sterile, 19th century, academic art. Perhaps their attitude was best summed up by Marc when he said, "Traditions are a fine thing, but what is really fine is to *create* a tradition, and not just live off one."

The *Blaue Reiter* was very short-lived as a formal group. World War I put an end to it. Two of the most potent members of the organization, Marc and Macke were killed in the war. When the war ended, each of the artists who were still alive went his own separate way.

Besides the early Expressionists who have already been noted, mention should also be made of significant artists associated with the general movement of *Expressionism* at a later time such as George Grosz, Max Beckmann, and Oscar Kokoschka.

At first glance the visual vocabulary of the Expressionists and the Fauves seems to be very similar. What distinguishes them formalistically is a frequent tendency toward the use of powerful *linear* networks in the compositions of the Expressionists. In addition, the Expressionists generally made much greater use of blacks and browns as colors then the Fauves. Furthermore, to a degree that must actually be seen to be understood, many of the Expressionists made compositions that are packed with incisive, often jagged forms. Their shapes and colors feel fractured and splintered. While your sensibilities are energetically stimulated by the Fauves they are first wrenched apart and then split to pieces inside of you when you get in close touch with the art of the Expressionists.

The most important aspect of *Expressionism* was its pre-World War I Germanic temperament. Unlike France, where *Fauvism* de-

veloped, Germany has an artistic continuity going back for centuries in which emotional and creative force are joined together in a unique mystical union. Above all else, a sense of vivid feeling and spirituality forms the foundation of this tradition. It may be recognized in the Gothic transcendentalism of an early artist like Grünewald. It may also be felt in the best of German music, literature, and poetry that has appeared across the years. It is an approach that is concerned as much with the *soul* as with vigorous compositions. But mostly, it is an approach that seeks to be free of esthetic pretense and preciousness.

Even though *Expressionism* was definitely a German art movement during the early years of the 20th century, it is also important to note the art of Georges Rouault who lived and worked in France

28 Erich Heckel *Portrait of a Man* Multicolor Woodcut, National Gallery of Art, Washington, D.C. (Rosenwald collection). Instead of a photographic likeness Heckel presents us with a complex psychological state in this picture of a man.

29 Georges Rouault *Christ Mocked by Soldiers* 1932, oil on canvas, collection, The Museum of Modern Art, New York. The tragedy of man's inhumanity to man is treated with soul searching depth in this canvas by Rouault.

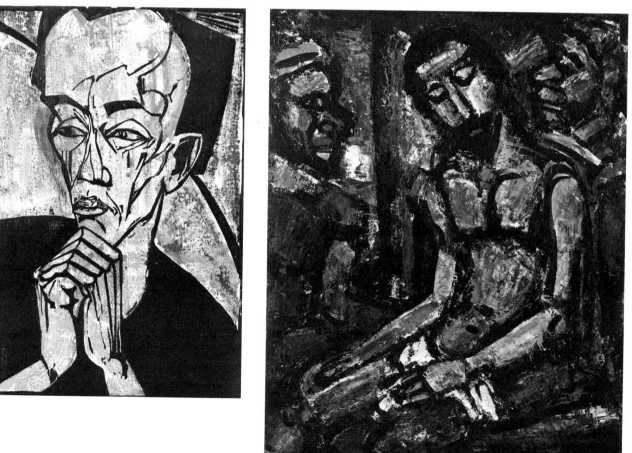

28

29

rather than Germany. At first, Rouault had been associated with the Fauve group of painters. But, when his work became increasingly subjective, the over-all feeling of his compositions took on a distinctly Expressionist flavor even though Rouault was never an official member of either the *Brücke* or *Blaue Reiter* groups.

At times, the forms of the Expressionists strike spectators as being overly abrasive and harshly distorted. Often, a sense of impulsiveness and frantic action seems to have been unduly exploited in realizing a given piece of work. Frequently, a taste for the weird and the fanatical makes an appearance in their art. Without doubt, all of these characteristics are there. For some people they add up to a sum of shapes and colors too repulsive to bear. For others, they go far in heightening the emotional and visual impact that Expressionist art is so uniquely capable of providing.

8 | Cubism—dynamic visions of a universe in flux

The fundamental facts of life today are very likely what they were at the dawn of history. Nevertheless, even though human biology and psychology have remained fairly constant, the style of life we experience now is clearly not the same as it was in the past. Obviously, conditions have changed over the years. Quite possibly, the world has never before been in such a state of ferment.

How should an artist interpret and express the currents of experience flowing through the 20th century? With what means can he capture the pulse-beat of life in the machine age? Perhaps one strong answer to both of these questions was supplied back in 1907 with the invention of *Cubism* by Pablo Picasso.

Like such contemporaries as Einstein, Freud, and Marconi, Picasso was an explorer. However, he was not an explorer in the manner of a mathematician or a scientist. His vision of reality was not arrived at with detached logic or impersonal objectivity. Employing a fertile imagination and a keen taste for the intuitive he explored the possibilities of creating new ways of seeing. As he did so he illuminated areas of human awareness with a unique kind of advanced perception which others could then follow and either confirm or deny.

Picasso did not create *Cubism* overnight. It took time for him to get ready. He had to study art and he had to find himself. As he worked at learning to be a painter he moved through several early phases of development in which his sensitivities and powers of expression were gradually sharpened and then refined.

The concept that came to be called *Cubism* was based upon a complex of several sources. The most important of them was the art of Cézanne. The old master of Aix had established the fact that a

stretched canvas was a *flat* surface. He had also established the notion that paint spread on such a surface was always *paint* and not paint pretending to be something other than itself. Furthermore, Cézanne had gone on to show that the integrity and identity of a painted design was a reality sufficient unto itself; it did not need to resemble the appearance of the subject matter represented by the design. The other sources upon which *Cubism* was based were examples of so-called "primitive art" which Picasso had studied. In early Iberian sculpture and African masks he discovered ways of articulating form that were bold, direct, and richly inventive. Like the art of Cézanne, but with a character of its own, the "primitive" art had a sense of monumentality. It had grandeur without being grandiose. Apparently, the monumentality came from the way the form was rendered and not from pompously inflated subject themes.

Cubism was begun by Picasso in 1907. He was soon joined by the former Fauve painter, Georges Braque. Beginning where Cézanne had stopped they took a new look at art and at their world. Their view of the world was then translated into a new grammar and vocabulary of vision. As they abandoned the external appearance of nature they proclaimed a new reality in which art elements depend upon their relationship to each other for their validity. They replaced the old disciplines of the painter with new ones. Above all, they placed premium upon the creative role of the artist. Of course, they did not completely throw away every traditional criterion of quality in esthetic form. For example, such timeless virtues as sound craftsmanship and sensitivity in the handling of materials were not discarded at all.

The decisive turning point came in a large, unfinished canvas by Picasso titled: *Les Demoiselles d'Avignon*. The title is useful only as a reference label for the work. It has little to do with what was significant about the picture as a painting.

When Picasso started to work on the canvas he was interested in developing a picture of five figues in a setting. However, as he got deeper and deeper into the relationships of the shapes to each other the shapes became more important than the figures they were originally supposed to represent. Likewise the setting in which the figures were to be located lost its initial representational significance. Soon, the setting also had dissolved into shapes that function chiefly as elements in the design of the over-all composition. In the final analysis, only one purpose was served by the use of the models and the setting—that was to provide Picasso with a point of departure which could be converted into a sophisticated tapestry of painted patterns. Those patterns are uncanny in their capacity for merging

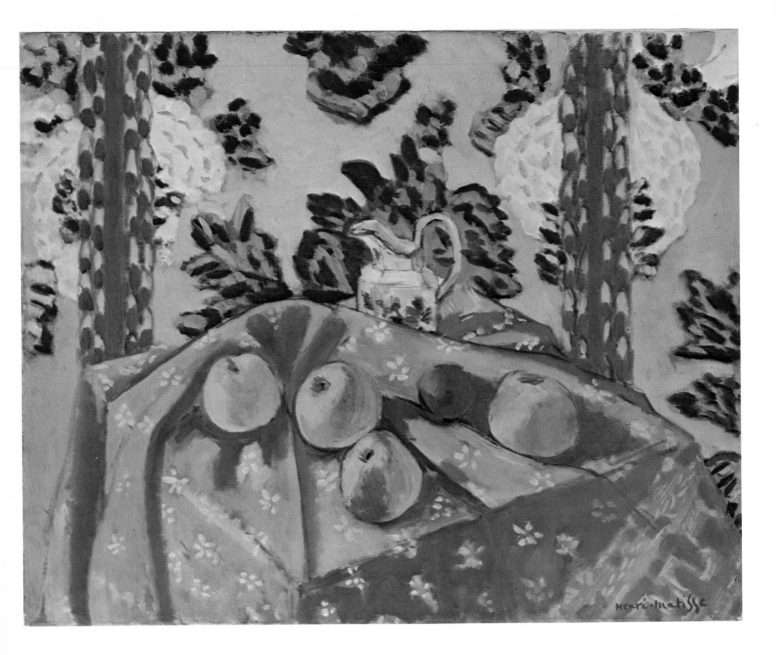

Henri Matisse *Still Life: Apples on Pink Tablecloth*, oil on canvas, National
Gallery of Art, Washington, D.C. (Chester Dale collection).

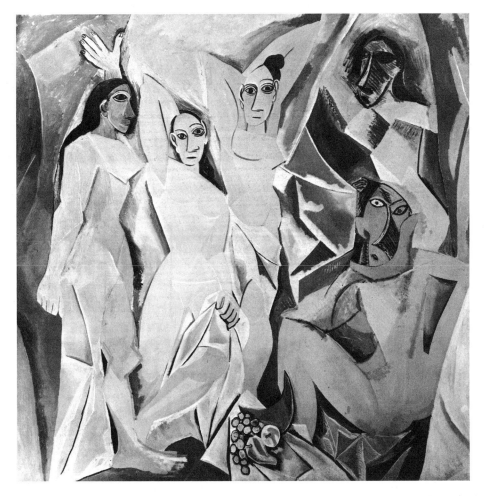

30 Pablo Picasso *Les Demoiselles D'Avignon* 1907, oil on canvas, collection, The Museum of Modern Art, New York (Lillie P. Bliss bequest). Out of Picasso's search for a new language of vision, Cubism was born.

into each other, moving apart, and then coalescing again into ever-changing new relationships of form.

The impact generated by the painting always remains startling—even when it has been seen many times. Obviously, it does not show us how women really might appear. Instead, the figures are somewhat reminiscent of the figures fashioned by ancient Egyptian artists on temple walls or in burial chambers. In that art from the past, an important figure (for example, representing a deity, a king, or a member of the nobility) was not treated naturalistically. Instead, the figure would be composed in such fashion that certain key portions of the anatomy would be presented in their most striking, most imposing visual aspects. Typically, such a figure might show a profile head with a front-view eye—a front view of the chest with a

side view of the arms—and, to complete the picture, the hips and legs rendered in side view. Some people find such a formulation to be awkward and repulsive because it is such a severe distortion of natural appearances. That may be, but the impact of a figure thus represented is clearly quite powerful—indeed, more powerful than a naturalistic appearance might be. Incidentally, such an ancient abstraction was not the result of caprice, accident, or the inability of artists to render naturalistic appearances. There are also examples of painting by ancient Egyptian artists that *are* naturalistically rendered. And, Picasso too, has frequently provided evidence that he can render figurative forms very descriptively when his expressive needs have required such a treatment.

It is interesting to note that *Les Demoiselles d'Avignon* was never quite completed. Certain areas of the painting have not really been successfully resolved. For example, the colors leave much to be desired. The sickly flesh tones appear like a hangover from Picasso's earlier "Rose" period when he had been using various pink colors in great abundance. Furthermore, the figures with the African mask-like heads on the right do not quite gel with the three figures on the left. However, the singular significance of the picture comes from the fact that it was a major breakthrough to a new way of thinking about form. When it is compared with a late Cézanne painting of figures for example, it soon becomes clear that Picasso had, in fact, moved on from where Cézanne had stopped. In the Cézanne picture there is still a design made of figures in a landscape. The figures and the landscape never quite become one fully crystallized visual unity. The sense of transformation from subject matter to design initiated by Cézanne was finally brought to complete realization by Picasso.

Les Demoiselles d'Avignon was a primitive beginning. Little by little, Picasso explored the possibilities he had opened up with his daring breakthrough of 1907. By 1908, Braque had joined him. Together they investigated abstract representation where the appearance of people, places, and things are changed entirely into elements that work together structurally in any fully assembled composition. From 1908 to 1912 Braque and Picasso dissected landscape, figure, and still life elements into esthetically interpreted bits and pieces of shapes, textures, or tones. They would then fit the newly fashioned fragments together into a design as soundly engineered and well regulated as a piece of machinery. You look at their work from that period and you see how the parts mesh together with precision. The planes of color vibrate, expand, contract, advance, and recede almost as though they were living an independent life of their own.

Perhaps the most obvious visual fact of Cubism is the total absence of traditional perspective. The *space* of a Cubist painting is entirely different from spatial rendering in art since the Renaissance. Instead of trying to imitate the space of the natural world outside the canvas, Braque and Picasso projected a sense of *created* space. The space they opened up in their work was articulated by flat planes that are true to the nature of the canvas surface. They define volumes that quiver with life as your eyes pass from surface to surface; from transparent states to overlapping, opaque layers of painted form.

Beyond an invented sense of space, a most remarkable feature of these abstractions is the feeling of rhythm that pulses vibrantly within their structure. When you get in touch with the inner beat of the work you find yourself becoming emotionally aware of a dynamic universe. Ponder that for a while! After all, our heritage from the past has taught us to think of matter as being static. For example, our limited senses would have us believe we are solid—that we live on a solid, unmoving earth—that everything around us is firmly

31 Paul Cézanne *The Large Bathers* 1898–1905, oil on canvas, Philadelphia Museum of Art, W. P. Wilstach collection (photograph by A. J. Wyatt, staff photographer). Cézanne provided Braque and Picasso with valuable examples of how subject matter could be transformed into new and highly dynamic design statements.

fixed in place. However, if we are to believe what the research of modern physics and chemistry has to say about matter in the universe then the very opposite is true. The physicists and the chemists report that our limited senses deceive us about the actual nature of matter. They tell us that our unaided, uninstrumented perceptions, even at best, are gross and faulty. Basically, matter consists of energies in flux in space;—the earth does not stand still, it is moving very rapidly as it rotates on an axis and revolves around the sun. Everything in the universe, from the smallest sub-structures of the atom to the galaxy of which our solar system is but a small part, is also in motion. We may say we understand such facts when we read about them or hear about them. But, we usually reject them so far as our inner feelings are concerned. Emotionally, we find it very difficult to accept the notion that everything is in a fluid state. Perhaps that is why many people are deeply troubled by the Cubist vision. The thought of a dynamic rather than a static universe may be quite upsetting. Our sense of inner equilibrium may feel scrambled. Perhaps we prefer a comfortable archaic concept, no matter how fallacious it may be, than accept a contemporary truth. So often, people feel more secure when they turn back to outdated assumptions instead of confronting the present limits of knowledge with an emotional as well as intellectual honesty. On the other hand, if we can allow ourselves to make contact with the life of the forms in many an early Cubist work we may indeed come to experience the reality of a universe in flux. We may experience that reality deep down within the center of our sinews and not just on the dim level of vague, verbalized thought.

Early *Cubism* also identified the idea that objects in the world need to be seen from many different points of view simultaneously if they are to be grasped in their wholeness. In a typical work we may be introduced to a figure. We are not shown one single view as the figure might appear from one fixed vantage point of observation. Instead we are introduced to aspects of the figure as seen from above, from below, and from all sides—all at once. In some instances we even get to feel a sense of seeing through the figure as though the painting were an esthetic X-ray. This concept also tends to trouble those people who find such an approach unfamiliar and hard to accept. But, as a concept, doesn't such an approach clearly demonstrate that in order to know anything in its entirety we must know it as a completely integrated totality and not simply as a series of isolated fragments?

Perhaps one of the most important assertions made by the Cubist vision is the need for *order* in life at large. A Cubist abstraction does

32

33

32 Jean Metzinger *Tea Time* 1911, oil on panel, Philadelphia Museum of Art, the Louise and Walter Arensberg collection (photograph by A. J. Wyatt, staff photographer). Instead of imitating the appearance of three-dimensional details in natural space, the planes of paint articulate a created space that has a life of its own, in the composition.

33 Pablo Picasso *Man with Violin* 1911–1912, oil on canvas, Philadelphia Museum of Art, the Louise and Walter Arensberg collection (photograph by A. J. Wyatt, staff photographer). By 1911, Picasso had taken Cubism from semi-representation to almost total abstraction.

not present a haphazard, arbitrary close-up on some little corner of the world as it might look in a casual glance. Instead, we see the end result of thoughtful analysis by which a given subject has been put together very carefully. Everything in a Cubist painting is organized down to the last little square inch of canvas surface. Nothing is left to chance. Whatever may have been superfluous has been discarded. Only the essentials remain and they have been woven together into an entirely compact composition where each

part is related to every other part and where each part is also related simultaneously to the whole design.

It was not long before Braque and Picasso were joined by a host of other artists. *Cubism* (which was a name presumably applied in jest by Matisse to some of the early works in an exhibition) really had nothing to do with cubes. But, it was a fresh approach to using visual form and many artists felt that as a style *Cubism* offered them new opportunities to exercise their capacities for thinking and working imaginatively.

By 1911, Braque and Picasso had run the gamut from semi-abstraction to almost total abstraction. Their image content had gone from pictures where the subject matter was still self-evident to works in which reference to subject matter was transformed into arrangements that were almost pure designs. They had arrived at the edge of non-representational form but they never took the last step where subject matter would have been entirely abandoned. They have explained that their reason for stopping short of that last step was a fear that if they did so, their work would become "merely decorative." And so, in 1912, they moved back toward a more representational treatment of subject matter. But in every other way the new phase of their work was certainly an advance beyond their earlier accomplishments. This time they began to explore the idea of pasting bits and pieces of assorted materials like newspaper, labels, oilcloth, chair caning, wallpaper, corrugated cardboard, and wood grain board to their canvas. Such collage elements were integrated with areas of chalk or charcoal drawing and patches of color laid in with a brush. In some paintings, for the sake of textural enrichment, Braque and Picasso even worked sand into their paint. Once again, a whole new range of esthetic possibilities was opened up. Materials and patterns appeared with a degree of tactile intensity never paralleled before with brush and paints alone. The combinations of texture, pattern, color, and shape proved to be a refreshing burst of

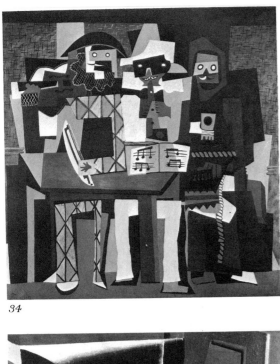

34

35

34 Pablo Picasso *The Three Musicians* 1921, oil on canvas, Philadelphia Museum of Art, A. E. Gallatin collection (photograph by A. J. Wyatt, staff photographer). Interlocking areas of flat color and pattern that vibrate beside each other frequently appear in paintings like this one from the period of late Cubism.

35 Juan Gris *The Open Window* 1917, oil on canvas, Philadelphia Museum of Art, the Louise and Walter Arensberg collection (photograph by A. J. Wyatt, staff photographer). Architectural features and the world outside of a window were the raw materials from which this abstract composition was carefully put together.

stimulation to many other artists. Among them were Jean Metzinger, Albert Gleizes, and Juan Gris. Each of these painters worked out a style of Cubism that was very much his own even though the general manner of abstraction was common to all of them.

The legacy of *Cubism* has also touched the lives of people who are entirely remote from the community of art. The concern for visual analysis, order, and inventiveness evolved by the Cubists has conditioned the development of architecture and the applied arts in the 20th century. Architects and product designers have learned many lessons from studying the work of the Cubists. As a consequence, all of us who live and work in modern buildings and use the products conceived and produced by the creative designers and craftsmen of our time have been touched to some degree by the thinking and the achievements of the Cubist painters.

36 Georges Braque *Still Life: The Table* 1928, oil on canvas, National Gallery of Art, Washington, D.C. (Chester Dale collection). Feelings of poetic grace and lyrical charm float across the sensitively brushed paint surfaces that make up this delicately balanced design.

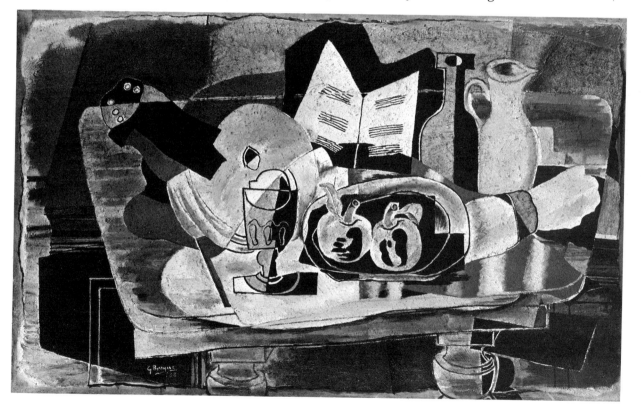

9 | Toward new horizons

Art movements rarely ever come into being on their own. As a rule, they are part of a continuity. They may even seem to be radical when they first appear. Eventually though, they take their place in the unfolding of a tradition. For example, *Impressionism*, which had been nurtured on the work of such forerunners as Manet, Constable, Turner, and Delacroix, looked very much like a totally new movement when it first appeared in the exhibition scene. But, as time went by, Impressionist art became widely acceptable and also—somewhat sterile. Through the creative efforts of the Post-Impressionists, *Impressionism*, which had grown stodgy and precious, was soon transformed and reborn. In a similar fashion, *Cubism* was a movement that virtually had to come into being because of the efforts of such painters as Cézanne and Seurat. Also, like *Impressionism*, early *Cubism* grew stereotyped and shot through with tiresome clichés. And so, once again, artists appeared who were able to take *Cubism* on to a next step of development. Loosely, they may be referred to as Neo-Cubists just as Cézanne and Seurat recreating the old *Impressionism*, were called *Neo-Impressionists*. The Neo-Cubists should not be thought of as comprising *one* single movement. Instead, they all went their own particular way. What they did share in common with each other was a debt to the early Cubists because early *Cubism* was the source of their own later work.

Of the many artists who advanced beyond the *Cubism* of Braque and Picasso, the best known and most widely celebrated has been the painter Marcel Duchamp. While the art of the early Cubists was predicated upon a dynamic vision of the universe, invariably, the subject matter they generally selected was relatively still. For example, their typical models were motionless objects on a table top, a static landscape, or a figure at rest. In 1912, Duchamp projected the idea of using motion itself as the basis of a painting.

In his *Nude Descending a Staircase* it is not the undressed figure that matters, but rather the *movement* of the figure. As we examine the picture we become aware of a sweeping tide of shapes rushing downward from the upper right corner to the staircase landing at the lower left of the canvas. Negotiating a turn there, the vague suggestion of a moving figure may be seen proceeding down the stairs, directly in front of us, as she moves across our field of vision. If we try to find the figure taking a particular step we miss the whole point of the painting. But, if we can look beyond the figure and focus instead on the generalized sensation of movement we can experience a swaying beat in the rhythm of the figure as she travels through the created space inside the picture.

Speed and the machine age were the central concerns of *Futurism*, a school of art that started out around 1909 in Italy. The artists who made up the movement created forms that vibrate with the vitality of contemporary life. They were determined to abandon the past because, to them, the past was only a dead weight slowing down progress in the present.

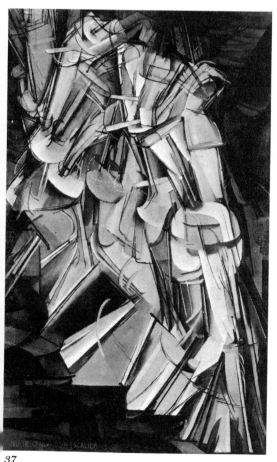

37 Marcel Duchamp *Nude Descending a Staircase, Number Two* 1912, oil on canvas, Philadelphia Museum of Art, the Louise and Walter Arensberg collection (photograph by A. J. Wyatt, staff photographer). The motion of a figure walking down some stairs rather than a still picture of a figure on the stairs is successfully suggested by the repeating shapes that range across the face of the canvas from the left side to the right.

38 Giacomo Balla *Speeding Automobile* 1912, oil on wood, collection, The Museum of Modern Art, New York (photograph by Soichi Sunami). Speed and the machine age are forcefully expressed here by dynamic elements that keep coming at us with no end in sight.

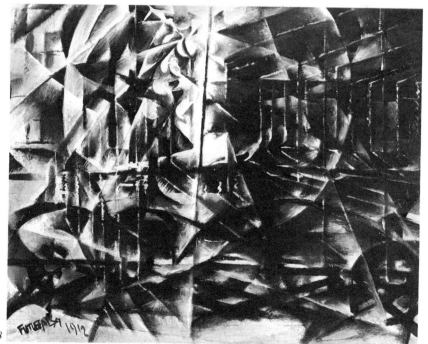

37

38

Visually, most Futurist art consists of forms that repeat themselves, almost endlessly, for the sake of suggesting active, agitated motion. Unfortunately though, *Futurism* had a fatal flaw. No matter how much the artists were concerned with expressing the kinetic dimensions of their subject matter their work always remained static. A still painting that tries to become like an automobile zooming down a street must, inevitably, be a contradiction in its own terms. For practical purposes, the expressional intentions of the Futurists were finally brought to realization many years later in the mobile constructions of Alexander Calder and others. In spite of that the Futurists should not be entirely dismissed. Their desire to come to terms with the present and their rejection of outmoded expressional formulas from the past did much to clear the air for other artists who came along after them.

Unlike the Futurists, Fernand Léger did not become entangled in the simulation of kinetic energies. However, he did turn to industry and mechanics to find a new source of richly expressive forms. His paintings almost murmur with the resonating buzz of a smoothly running engine. However, at the same time, they also have an intensely organic presence about them. And yet, they never pretend to be what they are not. For example, they are never really machines. They are always *paintings*—paintings put together like a sturdy power plant filled with people at work. If you approach his pictures with a receptive frame of mind you will find it difficult to avoid feeling the distinctive beat of life peculiar to this time in history when industrial production affects the lives of everyone.

39 Fernand Léger *The City* 1919, oil on canvas, Philadelphia Museum of Art, A. E. Gallatin collection (photograph by A. J. Wyatt, staff photographer). The sights and sounds of a busy city are convincingly reflected in Léger's inventive interpretation of the urban scene.

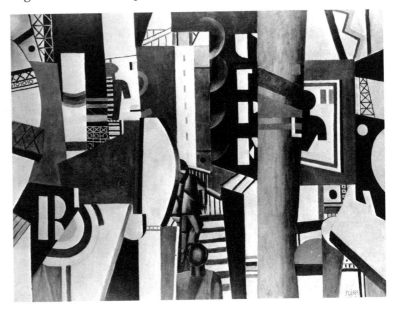

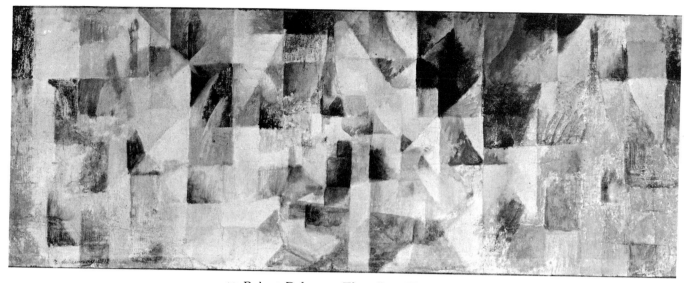

40 Robert Delaunay *Three-Part Windows* 1912, oil on canvas, Philadelphia Museum of Art, A. E. Gallatin collection (photograph by A. J. Wyatt, staff photographer). The visible world seen by his eyes has been made over by Delaunay into an abstraction where areas in tension to each other have been brought into a new state of resolution.

Orphism was the name of another movement associated with *Cubism* that began in 1912. The Orphists, Robert Delaunay and Frank Kupka, aimed to make visual poetry out of pure and scintillating colors. The visible world seen with their eyes was made over into compositions within which a range of colors in tension to each other were brought into a state of resolution. In effect, they joined the sense of structure suggested by *Cubism* with the brilliant bolts of color that had been liberated some years earlier by the Fauves. Two American artists, Morgan Russell and Stanton MacDonald-Wright, developed a similar style of approach which they named *Synchromism*.

Ultimately, the works produced by these various schools went far in revising the original lexicon of *Cubism*. Eventually, it became evident that traditional subject matter references were like a brake holding back the evolution of new expressional forms. Clearly, subject matter had to be stripped away entirely if artists were to fulfill the promise augured by their increasing reliance upon esthetic intuition in creative action. Furthermore, since the turn of the century, still photography had been augmented by the motion picture camera. It soon became clear that there was little need for the painter to make representational pictures when they could be made more faithfully and efficiently with the mechanical shutter, lens, and film. It therefore remained for the artist to open up new worlds of personalized vision that were distinctly beyond the scope of a mechanical gadget like the camera.

10 | The pursuit of purity

Like a tidal wave washing in toward the shore, certain art movements *must* move forward. Once their momentum is started, they cannot stop. That was how pure, non-representational art evolved. *Fauvism*, *Expressionism*, and *Cubism* had been great liberating movements from which artists with a pioneering vision were able to learn a great deal. The lessons they learned helped them push back the limits of what was known as they sought to develop what was esthetically unknown.

Two main approaches to non-representational form came into being. The first, established by the Russian painter, Wassily Kandinsky, was an outgrowth from German *Expressionism*. The second, which consisted of such schools of thought as *Constructivism*, *Suprematism*, and *de Stijl* were logical outgrowths from *Cubism*.

Kandinsky is generally considered to be the first artist of modern times who consistently worked in a vocabulary of pure, non-representational form. Delaunay and Kupka, to name some others, also arrived at non-representational modes of vision somewhat after Kandinsky (as did some other artists, even before Kandinsky) but, they did not continue to constantly cultivate the pure idiom with the dedicated regularity of Kandinsky from 1910 until his death in 1944.

Kandinsky had been in the forefront of German Expressionist art from about 1908. Since 1911, he had been the chief figure in the famous *Blaue Reiter* group in whose exhibitions he had actively participated and in whose almanac his writings were published. Like other artists before him, he was concerned with giving voice to the *spirit* he felt within himself. As his work developed, the reproduction of the visible world gradually melted away from sight. Finally, Kandinsky came to the conclusion that any references to material objects, no matter how abstract the reference was, only got in the way of the spiritual content he wanted to project.

Kandinsky believed that a spiritual reality is resident in all people. But, regardless of how much that spiritual reality is alive and meaningful inside a person, it is invisible to others because it is non-material in its make-up. Kandinsky felt that painting provided a vehicle for making spiritual realities visible, which then made it possible for them to be shared. He came to feel very strongly that one should not depend upon the appearance of material realities in order to express spiritual realities since the one must inevitably comprise the integrity of the other. In pursuit of the most direct forms with which to express the spirit, he came to the invention of a completely pure vision.

In 1910, the same year in which he painted a work entirely detached from reference to the object world he also wrote a book which he titled: *On the Spiritual in Art*. For the first time, a justification was formulated in print in support of a painterly means of expression which was entirely pure in character without becoming merely decorative. In large measure, he compared his approach to painting

41 Wassily Kandinsky *Little Painting with Yellow* (*Improvisation*) 1914, Philadelphia Museum of Art, the Louise and Walter Arensburg collection (photograph by A. J. Wyatt, staff photographer). Through a painting like this one, Kandinsky felt that spiritual realities could be externalized which then made it possible for them to be shared with other people.

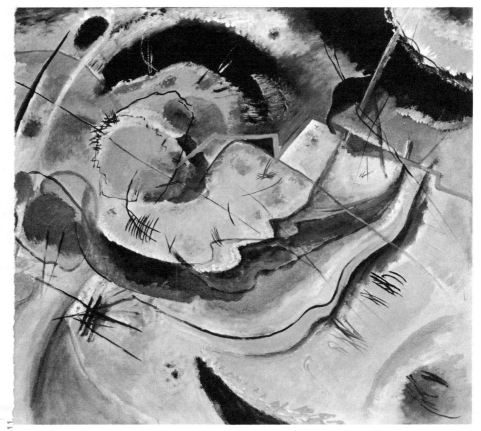

with the approach used by composers when they create music. Kandinsky spoke of colors as being like musical notes for the expression of emotional experience. He pointed out that his *visual* music was a means for putting the feelings in his soul in touch with the souls of other interested and responsive people who came to see his work.

Following World War I Kandinsky returned to Germany after having been in Russia for some years. In 1922 he accepted an invitation to teach at the Bauhaus, a school of art, architecture, and design. During the Bauhaus period Kandinsky developed a more controlled vocabulary of forms in contrast to his earlier highly spontaneous compositions. In his last years, all sorts of fanciful configurations blossomed forth from his brush. Without exception, they are delicately balanced compositions in which such contrasting tendencies as lyrical rhapsody and a tightly woven sense of order have been successfully resolved.

While the Cubists had been able to go far in liberating their vision they still bound themselves to an object oriented world. As far as the evolution of their art was concerned they could never manage to break through to purity in form. They were afraid that the complete detachment from object references would dilute the intensity of their expression. They felt that purity would lead to mere decorativeness. Apparently, they failed to see that many works, grounded in subject matter, became "merely decorative" because of shallow emptiness and superficial involvement by the artists who made such works. By comparison, the history of art is sprinkled liberally with examples of non-representational form (usually in architecture) that are intensely powerful, deeply moving, and decidedly non-decorative. Typical examples that immediately come to mind are the horizontal-vertical structures of Stonehenge and the pyramids at Gizeh in Egypt.

The pursuit of purity by Piet Mondrian was an effort to step from abstraction toward the creation of a concrete art. Instead of an abstraction of subject matter, Mondrian sought to express the ultimate realities underlying the over-all universe with a language of invented relationships in pure form.

Mondrian's work in painting followed a gradual and logical evolution from descriptive rendering or illustration to a completely pure plastic esthetic. He was acutely aware of the transformations that were taking place in the arts and the sciences and he knew that these changes were evidence of a world in flux. The immediate springboard for Mondrian's mature work came from the lessons of *Cubism* which was itself a movement that reflected changes that were occurring as the twentieth century replaced the nineteenth.

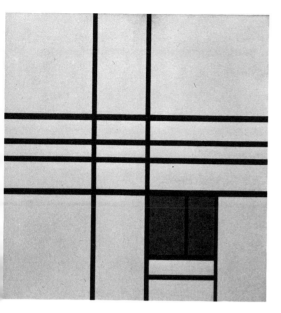

42 Piet Mondrian *Composition 1936*, oil on canvas, Philadelphia Museum of Art, the Louise and Walter Arensberg collection (photograph by A. J. Wyatt, staff photographer). In his desire to rise above the trivia of ordinary everyday events Mondrian created an art based upon ideal, universalized realities.

While other artists often gain the richness of their effects by an additive process of superimposing layers of paint upon each other until a stage of fulfillment is achieved, Mondrian gained his intensity of expression by means of a deductive process, working consistently toward abbreviation until he reached a simple common denominator of vital visual power.

In 1914, with Theo van Doesburg, Mondrian founded an organization of artists, architects, and designers in the Netherlands called *de Stijl*. In English, *de Stijl* means *The Style*. The reference is to the common characteristics of form which all of the members made use of in their creative work: horizontal-vertical shape relationships and pure primary colors supplemented by blacks, whites, and grays. In addition to developing projects in collaboration with each other they also published a magazine called *de Stijl* in which they enunciated their philosophy of art and design. Stated very briefly, they discussed the need for an integration of the fine and applied arts in order to achieve a more qualitative sense of life in Western society.

Looking at Mondrian's work for the first time causes many people to wonder what could ever possess a man to make what some have called, "cold and lifeless paintings." Occasionally, there are those who presume that these canvases are merely linoleum pattern designs, city street diagrams, pictures by someone who has spent too many years behind jail bars, or mysteriously symbolic crisscrossings by someone with a stubborn Messianic complex. While such assumptions may be understandable, they are all erroneous. As he has explained at great length in his own writings, Mondrian was not concerned with specific objects. His interest lay instead with expressing the sense of order he found in all of nature. Consequently, he eliminated from his work all references to anything in particular and focused his energies upon creating a body of forms that would be universal and transcendental in character.

In his search for a new vision—one appropriate to the expression of an ideal sense of reality, he arrived at three basic premises. First, he decided to make use of *only* horizontal and vertical shapes in relationship to each other. This decision was based upon his opinion, that such forms presented the most radical possible reduction of terms which were capable of projecting the most powerful counter tensions since they are the most opposite from each other as forms can be.

Therefore, they present the greatest challenge toward resolution. (Incidentally, they also reflect the ultimate dualities that exist in nature—such as life and death, right and wrong, hot and cold, night and day—which need to be continuously understood and resolved according to the assumptions implicit in Mondrian's esthetic.) Obviously, working in such fashion became a living embodiment of the idea of reaching for perfection. Second, for the same reasons, Mondrian elected to work only with the primary colors (red, yellow, and blue) coupled with blacks, whites and grays. Like horizontal-vertical shape relationships, such colors are as opposite from each other as colors can be. Working with such extremely simplified elements made it possible for Mondrian to invest a profound depth of intensity in his mature canvases because there was nothing else present in the work to provide any visual distractions. His compositions are there in their own terms as pure shape-colors with an independent existence of their own in any particular piece of his work. What lends animation to his forms was the third factor that he introduced to his art and that was a feeling of dynamic equilibrium. The contrasting tensions of shape and color brought into resolution with each other quiver with rhythm that always has an identity peculiar to itself. It is as though the parts of his paintings are all set in place but they are also vibrating in motion at the very same time. Perhaps a good comparison is provided by the solar system. The sun revolves on its axis and each planet rotates on an axis of its own while it is also moving around the sun. In turn, the system as a whole is also in motion as part of a galaxy which is also in motion. As all of those bodies move about they are also regulated and organized in relationship to each other. They are dynamic and yet they are so tied together that they do not fly apart in all directions.

Mondrian was very interested in expressing feelings about laws that he felt were fundamental to the order of the over-all cosmos. To do that effectively he had to cast aside the notion of expressing his individual self-hood. Transcending the particulars of petty personal experience he aimed to create an art that was concerned with ideal, universalized realities.

At first glance the shapes in a composition by Mondrian may appear to be fairly uniform. However, close examination will re-

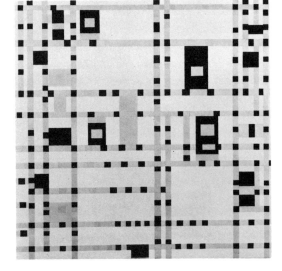

43 Piet Mondrian *Broadway Boogie Woogie* 1942–1943, oil on canvas, collection, The Museum of Modern Art, New York (photograph by Soichi Sunami). Syncopated rhythms will beat with life if you allow your eyes to follow the paths of movement suggested by the patterns of the painting. See color plate opposite.

Piet Mondrian *Broadway Boogie Woogie* 1942-1943, oil on canvas, collection, The Museum of Modern Art, New York (photograph by Soichi Sunami).

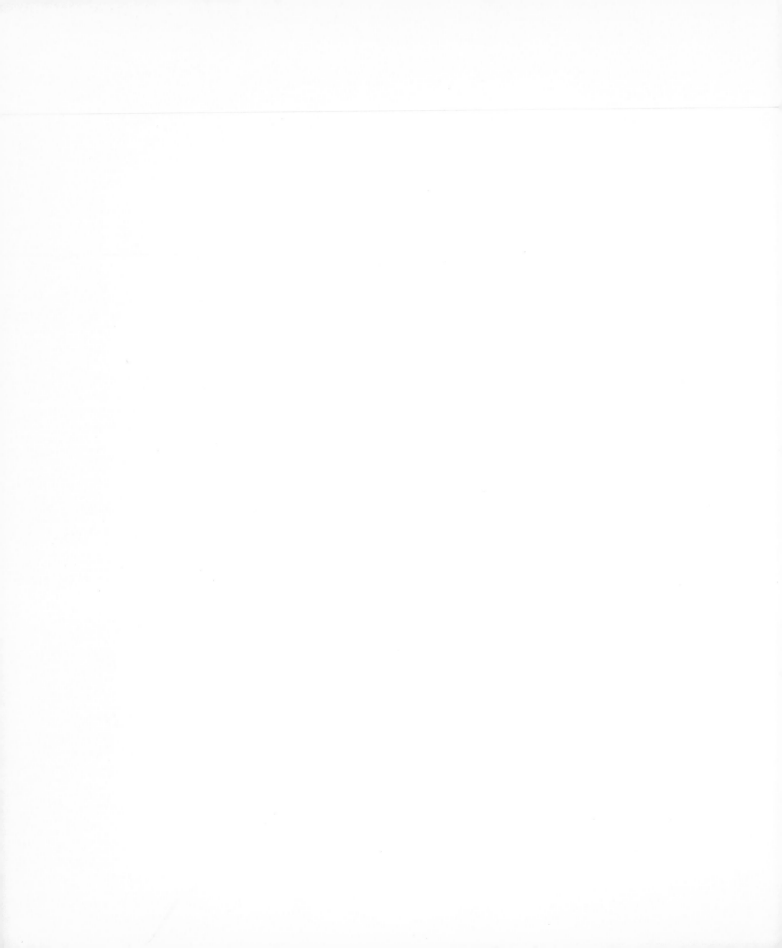

veal that no two areas are ever exactly alike. Obviously, more effort and thought have gone into the creation of such subtle relationships than is evident when initial contact is made. The more you look at his paintings the more you are likely to see how various areas and colors have been arranged for a feeling of balance and unity through the resolution of many, many tensions that make up any particular piece of his work.

The way in which a mature Mondrian painting functions is particularly well demonstrated by a work like *Broadway Boogie-Woogie*. In the *Boogie-Woogie* energy is released by the colors operating in counterpoint to each other. In turn, that energy opens up exciting movements across the two-dimensional plane as well as into the created space of the painting. As in *Cubism*, the created space of the painting is not like the natural space of the surrounding world in which we live. Instead, the space of the painting results from the volumes that are generated by the advancement and recession of planes of color situated within the painting. These movements do not occur in some helter-skelter fashion. Everything that happens, pulsating though it does, is still held together within the frame by an over-all sense of organization.

The *Boogie-Woogie* is composed of primary colors set in rectangular shapes dispersed throughout a regulated framework. Everything is brought together in precise and calculated relationships. Certain subtleties bear special observation. For example, where one yellow area is adjacent to another they are set apart from each other through variations of the brush stroke directions employed in painting the areas. Whites are as significant as the passages that separate them for they set up atonal visual complements to the smaller areas in color.

In the *Boogie-Woogie*, the organization itself is the painting. There are no hidden messages or esoteric symbols. The painting is what it is. Nothing is hidden. Nothing is obscure. The painting is not intended to be explained—it is meant to be experienced—by anyone and everyone who has eyes with which to see and is willing to work at using those eyes for seeing paint in action. The syncopated rhythms of the painting will immediately come to life and vibrate feverishly if one looks at them straightforwardly, without trying to figure them out intellectually. What the colors, shapes, and textures of the paint are doing has to be felt. The emotional charge communicated by the painting comes from the very nature of the kinetic tensions of the organization. There are no romantic associations here to serve as secondhand emotional messages to be transmitted. The *Broadway Boogie-Woogie* does not try to be literal like a novel or

scientific like a theory or mathematical like an equation. It is a painting, alive with a visual identity of its own.

The only reason for the word Broadway in the title is the fact that Mondrian was working at the time he made the painting in a studio just off Broadway, a street in New York City. By the same token, the term: *Boogie-Woogie* has only a remote reference to the jazz tempo of the forms as they function to bring out the rhythm of the painting.

One must approach a painting like *Broadway Boogie-Woogie* as one might approach a Platonic dialogue. The primary movements of creation have been searchingly felt and condensed into an eloquently expressive statement. The plastic forms are used as a wise man might use words—only when they have something fundamental to say.

The search for a language of orderly expression undertaken by the *Stijl* group also took place at roughly the same time in Russia. Two movements in particular were dedicated to making a new, pure vision. One was called *Constructivism* while the other was named *Suprematism*.

Like Mondrian, the Constructivists—Naum Gabo and Antoine Pevsner—evolved their approach to form out of *Cubism*. The unsettled political climate of post World War I Russia had something of an effect on the emergence of the new movement. The communistically oriented government that first came to power in Russia in 1917 placed premium on almost everything that was significantly revolutionary in the arts as they sought to clear the air of everything from the past and the days of Czarist power and authority. The Constructivists left the craft of painting completely behind as they replaced oils on canvas with such modern materials as steel rods, aluminum sheets, and plastic shapes of all kinds. But the materials they explored were the least revolutionary part of their approach. What was most radical about their efforts was the notion that external appearances could not show the ultimate essence of reality. According to the Constructivists, external appearances and even abstractions of external appearances merely present outward illusions to human senses. It was their claim that the true basis of reality existed in the internal invisible, infinitely varied *core structure* of natural forms. Such a sense of structure could only be apprehended intuitively and could be best expressed in metaphors arrived at by esthetic invention.

In addition to revealing and expressing the nature of the core structure in all form, the Constructivists also wished to project a value orientation. They were not content to merely reflect on reality. In addition, they aimed to suggest, on a poetic level as it were,

directions that reality *should take* if reality is to realize its own best rather than its worst potentials. As it was with the Dutch *Stijl* movement, the pursuit of ideals was central to the Constructivist philosophy.

The name of Kasimir Malevich has become something of a legend in *avant-garde* art circles. Perhaps more than any other artist, and before any other artist of this century, Malevich stripped painting completely bare of everything except the most basic essentials of the craft.

The suggestion of figuration all but disappeared from Malevich's cubist inspired paintings by 1913. By the end of that year, at an exhibition in Moscow, he showed a canvas consisting of a black square applied with fastidious care in pencil cross-hatchings on a white ground. The tension between the form and the field was gradually heightened, refined, and made ever more subtle. The peak of this evolution took place in 1919 when Malevich created and exhibited a painting called: *White on White.* It is an uncanny piece of work. Presumably, it ought to be of little account, and yet, it isn't. Of course, it takes time to adjust oneself to such a spare image

44 Kasimir Malevich *Suprematist Composition: White on White* (1918?), oil on canvas, collection, The Museum of Modern Art, New York. The tensions between a form and the field within which it is situated have been brought to an exquisitely subtle level of resolution in this painting.

and naturally, it will never be everyone's "cup of tea." But, those who are able to attach concentration and interest to the work find their efforts rewarded with an experience in seeing paint at work that is unlike anything else. Because there is seemingly so little to be seen, every tiny bit counts—the proportions of the one square to the other; the angles and movements formed by the location of the small square to its big brother; the relationship of the tones to each other which are so close that the very sensitive difference between them almost fades completely out of view if you blink your eye. While *White on White* may never become a popular painting it does provide a good example of how eloquently a painter can speak with the most minimal of visual language to those who are willing to be receptive.

What Malevich tried to do was free art from the heavy dead weight of object representation. It sounds easy to say that in words, but making a significant breakthrough, when there are no precedents to follow is far more difficult in terms of human expression and esthetic achievement than these words can really suggest. The important point is that Malevich's art is *not* empty. Rather, it is filled to the brim with a profound awareness of the absence of object reference or pretense. What remains is packed with the presence of paint living a rich, full life of its own, unencumbered by anything that is non-painterly. The sensibility of an artist in all its daring and willingness to try the untried and bring it to realization glows out of Malevich's work like the light of a brilliant beacon cutting through the darkness of a cloudy night. The label he applied to his work: *Suprematism* makes good sense when you realize that he was dealing with an art of supreme sensations—with levels of awareness that are beyond the everyday, ordinary world of experience.

As one might expect, the art of Malevich, Gabo, and Pevsner which was free of socialist or materialist associations soon fell from favor with the bureaucratic regime that came to control the Soviet Union. Before long, any painting or sculpture that could not serve a propaganda purpose for the Soviet state was unwelcome in the land. Gabo and Pevsner left Russia. Feeling that he had brought painting as far as it was possible to bring painting anyhow, Malevich stopped painting altogether. Until his death in 1935 he worked as a professor of art in the Leningrad Academy where he was able to teach and also carry out studies in experimental architecture.

Occasionally, it is suggested that pure art contributes to the dehumanizing tendencies which some critics claim are present in contemporary society. That may be. However, consider the contrary. Our most human abilities consist of capacities for bringing feeling

45 Antoine Pevsner *Developable Column* 1942, brass and oxidized bronze, collection, The Museum of Modern Art, New York. Energies move out in all directions from the central core of Pevsner's pure construction in space.

46 Naum Gabo *Spiral Theme* 1941, plastic, collection, The Museum of Modern Art, New York: Advisory Committee Fund. Lightness and transparency are very evident in this carefully crafted work made from clear plastic.

and thought together in depth within ourselves. Such abilities are certainly cultivated when we seek to respond to the interactions of shape, color, texture, and space we find in pure art. The more we exercise our personal potentials for perception, cognition, and emotional response the more we expand our own total experience. Such experience, by its very nature, is always individual and unique in each of us. To that extent, contact with pure art may well increase rather than decrease what makes any of us genuinely sensit ve and deeply thoughtful human beings.

11 | Dada—art born of agony and despair

For many artists and intellectuals in Europe and America, World War I was a time of horror and stupidity. They were thoroughly disgusted by the barbarism and inhumanity committed in the name of winning the war, regardless of sides. From their point of view there was no right side. They felt that war was a dirty business in which the value of human life was rendered totally insignificant.

The havoc and destruction inflicted upon helpless victims by the war were an outrage to sensitive and thoughtful people. Little wonder that tides of disenchantment with Western society in general soon spread across the borders between countries. Understandably, a nihilist outlook came to be adopted far and wide. "After all," asked many an artist, "how much good can there be in a society where the brutality and destruction of war are not only permitted to take place but are even justified with all kinds of verbal rationalizations?" In 1915 a group of painters and poets got together at the Cabaret Voltaire in the neutral city of Zurich, Switzerland. They were angry with the war and with the society that created the war. They knew that there was little they could do to change the society—but, they could speak from their hearts and express what they felt with all the intensity they could command creatively. Out of their wrath they forged a language of form that was vehemently against familiar, established art forms. They were not really against art. The main thrust of their complaint was actually directed against society at large. However, their previous experience had conditioned them to believe that art was supposed to be the highest achievement and expression of life going on in a given society. Consequently, when they reflected upon what was taking place around them, geopolitically and socially, they concluded that their society had gone completely

47 Jean Arp *Objects Arranged According to the Laws of Chance* (also called *Navels*) 1930, wood, collection, The Museum of Modern Art, New York. For Arp, arrangements produced by the play of chance became a new way of structuring a sense of order in solid materials.

out of its mind. And so, they bent their efforts to making art that was appropriate to the opposite of any rational art that was based upon the assumption of a supposedly rational world.

The name of the movement: *Dada* was arrived at by the play of chance. It was decided to employ chance because chance was the very opposite of reason, which they had come to hold in low esteem. (They considered reason a questionable virtue because Western society was presumably based upon the exercise of reason and yet that *reasonable* society could settle its differences only by waging war.) The word Dada is French for rocking horse—a child's play toy. Specifically, the name was arrived at by having someone in the group open a dictionary and pick a word at random. By following this anti-rational process of selection an art movement was suddenly (and somewhat dramatically) given a name.

Believing that Western society had touched bottom, the *Dada* artists set out to remake art—from the bottom up, as it were. They promptly rejected all tendencies toward what they felt to be most corrupt in Western society: the pretense of being logical and the practice of placing undue importance upon materialism. By contrast, the Dadaists, with their naive idealism, placed premium upon the exercise of intuition and a concern with anti-materialism in their work. They felt that none of the established values of Western society should be held sacred. With daring and a somewhat whacky sense of humor they were determined to shock the polite bourgeoisie who might come to see their art. In order to heighten the shock effect, they resorted to sources of form that were bound to be totally unexpected as art statements. Much of what they did was therefore self-destructive and consequently, self-defeating. However, in spite of their wild shenanigans they managed to liberate all sorts of new ways to shape form that have had a curiously lasting impact upon the art world even though *Dada* has long since died as a viable art movement.

Jean Arp, for example, made compositions of *torn paper* fragments. He also took beautifully carved biomorphic wooden shapes, placed them on a board base, and then shook the pieces about. He would repeat the procedure, over and over again, until he was satisfied—on an intuitive level, with the position relationship of all the parts. At that point he would attach the free elements to the base and perhaps partly with tongue in cheek title the whole object: *Composition Ar-*

71

ranged to the Laws of Chance. Obviously, on a verbal level, there is an impish suggestion of contradiction in the title—but, visually, the relationship between the parts, arrived at in part through the play of chance, is most handsomely composed.

Another little Dada movement got started in New York City. At the center of the stage was Marcel Duchamp, the painter who had earlier in his career attracted widespread attention with his painting: *Nude Descending a Staircase.* Duchamp's principal contributions to Dada consisted of a mordant wit, the concept of the "ready-made" or *found-object*, and a cultivated taste for expressional ambiguity. For example, at one time he exhibited a bicycle wheel mounted on a stool and called it *Mobile* which, of course, it *is* when the wheel is spun upon its axle within its frame. Furthermore, if we see that wheel turning around and around, we may find ourselves rather taken with the spinning motion and the gleaming reflections. In addition, we are stimulated to think anew about everything we can look at with our eyes in an industrial age. Of course, we may also ponder the meaning of a gracefully moving wheel that turns and turns and never goes anywhere. And yet, Duchamp did not select the wheel with the polished metal rim and dazzling spokes because it was a *modern* object, *per se.* Rather, he selected it because it was

48 Marcel Duchamp *Ready-Made, Why Not Sneeze Rose Selavy?* 1921, Philadelphia Museum of Art, the Louise and Walter Arensberg collection (photograph by A. J. Wyatt, staff photographer). The cage of marble lumps mixed with other odds and ends startles us and may well generate a chain reaction of imaginative responses if we are sufficiently able to play a part in the fantasy that Duchamp has created.

such a commonplace object and was therefore generally overlooked. Through his *act of selection* (directed by an esthetically oriented vision) he transformed that commonplace, everyday object into an uncommon, extraordinary art object. The exercise of sensitively thoughtful judgment and the making of an esthetic decision became a new kind of creative art activity. It is an especially adventurous and touchy matter because it veers so close to mere whim and the casually arbitrary act which in the hands of a non-sensitive clod can easily result in the emptiest nonsense. In effect, such an approach tells us not to ask what art is (or, as is usually the case, what art *once was*) but rather *who* is the artist and what is at the heart of his efforts. Clearly, such a "ready-made" kind of art first shocks and then challenges all of our previously held assumptions about what art is and why.

Other Dada objects by Duchamp included: *In Advance of a Broken Arm* (a suspended snowshovel); a reproduction of *Mona Lisa* with a mustache and goatee daubed in on "her" face and an impolite French acronym scrawled in at the bottom; and a whacky little wire cage filled with ivory lumps that look like sugar (but weigh much more), a thermometer, and a little cuttlefish bone—the whole works labeled *Why Not Sneeze?* Taken together, they were like a blow being struck for freedom in art.

In making ambiguous assemblages and by exhibiting "found-objects" as works of art Duchamp showed that the creative artist must be ready to detach himself from the prevailing demands of a smug society. The artist must be capable of rejecting the notions about what is acceptable as art in a society whose standards for art may be arbitrary, stereotyped, and archaic. Only then can the artist's personal integrity and creative drive be preserved.

Dada came to Germany following the war's end in 1918. The sense of frustration, futility, and waste then abroad in the land provided a fertile soil in which the Dada spirit could grow and flower.

In Berlin, George Grosz questioned every compromise with human values that had been taking place in his native land. In a sardonic little collage-watercolor titled *The Engineer Heartfield* Grosz pasted a picture of mechanical parts at work in the heart area of a caricature picture of an artist friend of his named John Heartfield. The mean looking little man stands all alone in a space that is remote

49 George Grosz *The Engineer Heartfield* 1920, watercolor and collage, collection, The Museum of Modern Art, New York (gift of A. Conger Goodyear). The pasted picture fragments of machine parts and the city street add a sardonic touch to this watercolor painting.

and isolated from the city outside. The sense of alienation that runs through the picture momentarily causes your own heart to almost grind to a halt with a wrenching of rusty gears.

The ultimate *Dada* master was Kurt Schwitters, an artist active in Hanover. Schwitters found his palette in the rubbish basket. Using scraps as art supplies he made collages which he called *merz-bilder* or trash pictures. Typically, they include ticket stubs, empty wrappers, announcements, and all kinds of assorted bits and pieces of junk assembled into compositions that are often unexpectedly subtle as the separate little parts work with each other to exquisite perfection.

The movement that started out as a revolution against reason, polite society, and conventional esthetics eventually ran out of steam. After a while the anger and the hurt subsided as the years following the war became relatively peaceful, and in some respects, until 1929, quite prosperous. • Out of the ashes that had once been *Dada*, all kinds of new developments were bound to rise. Among them were *Abstract Expressionism* and *Pop Art*. But first, as *Dada* was folding itself up and fading away the next new movement to appear on the scene, amply stimulated in its root development by *Dada*, was *Surrealism.* •

50 Kurt Schwitters *Merz Konstruktion* 1921, Philadelphia Museum of Art, A. E. Gallatin collection (photograph by A. J. Wyatt, staff photographer). Discarded scraps of rubbish become elements in a strange world of eerie three-dimensional reality.

12 | Fantastic art and surrealism—turning toward the subconscious

At roughly the same time that the *Dada* artists were making news in the European art scene another development, curiously parallel to *Dada*, was also taking shape. However, unlike *Dada*, this other development never became a formalized movement. Instead, it consisted of several decidedly diverse painters. Each, in his own way, was very much an individual. Nevertheless, there was a major similarity in their work. That one characteristic, shared in common by all of them, was a distinctive feeling for fantasy. With respect to that single feature, the work of three painters—Marc Chagall, Paul Klee, and Giorgio de Chirico—has been especially significant.

The canvases of Marc Chagall glow with enchantment, fire, and surprise. Fragmented memories and poetic ideas are juggled together in his paint surfaces. They are alive with lyricism and warmth. Other painters may become insipid and sticky with the syrup of exaggerated sentiment. Chagall does not. Apparently, he knows how to avoid such pitfalls. Over the years he has continuously exercised restraint and good taste in pictures that are always identifiable by their inventiveness and richly jeweled colors.

Frequently, a small scale format will cramp the expressive potentials of an artist who wants to make a big statement. But, in the hands of Paul Klee, a small format was admirably suited to a giant-sized capacity for personal expression. From the most secret centers of feeling within him, Klee was able to actuate compositions

51 Marc Chagall *I and My Village* c.1911, oil on canvas, collection, Philadelphia Museum of Art (photograph by A. J. Wyatt, staff photographer). Images remembered from his childhood in a little Russian village glow warmly in Chagall's picture.

75

52 Paul Klee *Jörg* 1924, watercolor, Philadelphia Museum of Art, the Louise and Walter Arensberg collection (photograph by A. J. Wyatt, staff photographer). Feelings of tenderness and delicacy slide gently through the fragile lines of this watercolor and ink drawing.

53 Giorgio de Chirico *The Poet and His Muse* c.1925, Philadelphia Museum of Art, the Louise and Walter Arensberg collection (photograph by A. J. Wyatt, staff photographer). Strange and haunted moods occupy the scene of paintings, like this one, by de Chirico.

filled with silent music and muted mystery. Without doubt, Klee has proven to be one of the most fertile creative artists of the twentieth century. His influence upon students, designers, and other painters is too great to be properly estimated. Only Chagall, Picasso, Matisse, and Miro have equalled his ability to recapture the fresh, enthusiastic, responsive eyesight of a young child. However, his art is not childish. Instead, one might say it is child-like. The difference between them rests in the capacity Klee had for transforming the vision of a child into pictures that reflect subtlety, wit, and inventiveness at a mature level of painterly achievement. One need only compare pictures made by children with the work of a

sophisticated and sensitive adult like Klee and the differences between them soon become patently obvious.

The ominous aura of a strangely haunted reality marks the paintings of Giorgio de Chirico from the period before the first World War through the 1920s. Recognizable elements are brought together in weird and puzzling juxtapositions. They are generally located within dreamy landscapes or interiors that seem to be sealed from the outside. The light in the pictures is usually diffused and somewhat chilly. By contrast with the light there are almost always some dense shadows sitting thickly like lead weights in any given scene. A mingled combination of lyrical serenity and troubled anxiety hovers with suspended stillness inside the peculiarly airless space of one canvas by de Chirico after another. All of his work seems to say that material objects, no matter how real they may appear to be, are essentially unreal and meaningless; that there is a larger, non-material, metaphysical reality located somewhere beyond the apparently real world. It is as though de Chirico's work tries to tell us that the world we generally take for granted to be real is actually an apparation—a pale phantom masking an all inclusive reality we can see only when we look beyond the overt appearance of things.

As in the art of de Chirico, fantasy was also a foundation for the Surrealist movement. The artists and writers associated with *Surrealism* challenged the picture of reality perceived by the ordinary conscious mind of the typically normal but otherwise unimaginative man in the street. They insisted that there was another reality—*a super reality*—perceived by the subconscious and the unconscious as they function beyond the limits of conscious awareness. It was their feeling that the insights arrived at by all the senses—the fully conscious ones as well as the non-fully conscious senses—present the true, *total* picture of reality. They rejected the image perceived by conscious awareness alone since they felt that at best, such awareness was only a limited picture of reality.

Considerable support for the Surrealist position came from the writings and research of Sigmund Freud. As a psychoanalyst, Freud had shown that dream experiences, for example, had much to do with revealing the true nature of a person's deepest feelings and of course, dreams are beyond the range of logical, conscious awareness.

As an art movement, *Surrealism* was nurtured by two sources. The first was the *Dada* spirit with all of its liberties. The second was the approach to making art which had already been staked out by such artists as Chagall, Klee, and especially de Chirico. Moving out on their own, the Surrealists sought to create a systematic pro-

cedure for reaching a visual twilight zone in which fanciful form and fantastic feelings could mesh together and give voice to an artist's urgently compulsive needs for self-expression. ❧ Because the Surrealists placed so much importance upon expressing their selfhood, the forms that appear in their work are as diverse from each other as the personalities of the artists who comprised the movement were different from each other. However, regardless of their differences, all the Surrealists wanted to open up an internal stream of subconsciousness and let it run freely into their paint. By such a process they hoped to liberate the energy of what they felt was a life force bubbling within them. That energy was then supposed to free the impulses toward sincere expression that are *normally* kept hidden within the artist by such censors as reason and custom or other agencies of social and moral restraint.

Probably the best-known Surrealist painter is Salvador Dali. With meticulous brush strokes he has provided hand-painted snapshots from the depths of his most troubled dreams. By illustrating his nightmares he has managed to esthetically exploit what he proudly identifies as his neurotic personality. Because he does not pretend to be other than a flagrant exhibitionist his pictures *read* like a visual catalog of Freudian dream interpretation symbols. Strangely enough, once you have seen a Dali painting the image in the forms becomes deeply planted in your memory. We wonder why that should be so. Apparently, there is more to the forms than we fully understand or can explain consciously. Perhaps some kind of direct connection is established between the subconscious of Dali and our own subconscious. How else can we explain what makes his pictures so terribly unforgettable? ❧

The painting style of Yves Tanguy is also marked by a sense of photographic precision. Like Dali, his forms are highly descriptive. However, they are not the same. Tanguy's forms have an uncanny openendedness. Because they are not copies of specific objects they lend themselves to an infinity of possible interpretations. Each of us who comes to see them attaches different meanings to what we see. It is quite obvious that Tanguy's paintings are not pictures of things we are ever likely to actually see anywhere. Yet, because they do exist on canvas with such stunning verisimilitude we come to believe that they *do* exist—somewhere—even if we have never seen them; even if we never will.

❧ Of all the Surrealists, the one who has come to be most admired by other artists is Joan Miro. At one and the same time, his art is broadly universal and profoundly personal. Oftentimes, his images look so simple; even childish—and then, slowly, we come to see that

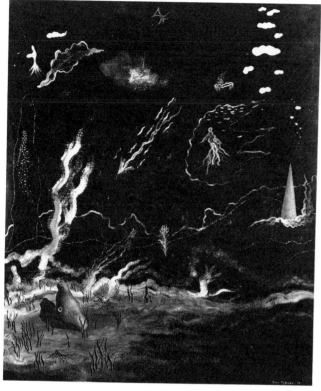

54 Salvador Dali *Agnostic Symbol* 1932, Philadelphia Museum of Art, the Louise and Walter Arensberg collection (photograph by A. J. Wyatt, staff photographer). A picture by Dali is virtually always a hand-painted snapshot from the center of his deepest dreams.

55 Joan Miro *Painting* 1933, Philadelphia Museum of Art, A. E. Gallatin collection (photograph by A. J. Wyatt, staff photographer). Elements of imaginary anatomy seem to be drifting ominously across the space of the canvas plane.

56 Yves Tanguy *The Storm* 1926, Philadelphia Museum of Art: the Louise and Walter Arensberg collection (photograph by A. J. Wyatt, staff photographer). Though they are not descriptions of specific objects, Tanguy's paintings often look like photographs—especially at first glance.

79

while they may look childish they are not really childish at all. As a matter of fact, what may start out looking rather comical soon turns into forms that are incredibly pithy and terribly sad. Invariably, the forms have a built-in shock force that is part wit and part nightmare. But always, they are also impeccable orchestrations of incisively created line, color, shape, and space.

Clearly then, though it was a unified art movement, Surrealism was not a single painting style. Rather, it was an individualized way of digging into the super-reality of total awareness. Filled with random streams of free association, Surrealist art can open up wide new visions for us if we are willing to participate imaginatively in the looking process.

13 | Voices of protest—the eye of criticism turned upon society

The artist does not live in a vacuum. Unless he becomes a hermit he is part of society at large. Because he is an acutely sensitive person he may see much that others might miss. For example, during the years between the two world wars such factors as economic depression, the rise of dictatorships, and political turmoil caused many fractures to take place in the social milieu of the Western world. During such a period of upheaval it was inevitable that artists would look out on the world around them and then comment critically upon what they saw and how they felt.

George Grosz used the sharp point of a pen dipped in ink to speak bitterly about the brutality and inhumanity he found in his native Germany. In a drawing like *Fit for Active Service* he showed the depths to which the military can sink in a supposedly civilized society. His figures of arrogant army officers, a fat doctor proclaiming that his patient (the skeleton) is ready for induction, and the blindly servile clerk, orderly, and guard speak as clearly today as they did when they were drawn in the dim days of 1918. With telling sarcasm, the inked lines complain about so much that is still wrong and rotten in the world.

In a similar vein, an artist like William Gropper could attack the pompous side of a great democratic legislative body like the senate of the United States with a lithograph titled: *For the Record*. In the picture, as the roaring senator thunders and rails in a speech to be

57 George Grosz *Fit for Active Service* 1916–1917, ink on paper, collection, The Museum of Modern Art, New York (A. Conger Goodyear Fund). The sarcastic pen lines of George Grosz complain bitterly about the military establishment at its worst.

58 William Gropper *For the Record* 1940, lithograph, collection, Philadelphia Museum of Art (photograph by A. J. Wyatt, staff photographer). The caricature of a roaring legislator is a pithy social comment by a perceptive critic of modern politics.

59 Ben Shahn *Miners' Wives* 1948, collection, Philadelphia Museum of Art (photograph by A. J. Wyatt, staff photographer). The bitter grief of Shahn's painting cries out against the cruel exploitation of down-trodden people everywhere.

58

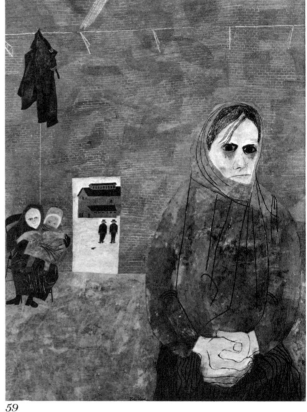
59

entered in the Congressional Record, we see his colleagues half asleep or worse yet, engrossed in a newspaper. The satirical irony of the picture has the sharp, biting twang of a vigorous editorial cartoon.

The American painter best known for being responsive to the conditions of everyday life is Ben Shahn. He came to prominence early in his career because he painted pictures that dealt with issues of vital social concern. Few other artists of such international reputation have allowed their social-political sensitivities to dominate

82

their art to the degree that Shahn has. Typically, *Miners' Wives* presents a picture of human tragedy. Two coal company officials are seen through a door walking away in the far distance. They have come to report the death of a miner to his family. Within the bleak interior of the foreground we find ourselves close-up to a figure of the dead miner's wife. The clothing she wears may warm her bones but not the icy chill of her innermost feelings. The piercing black of her eyes and her fingers—intertwined tightly together—testify to the intensity of her grief and loneliness. The placement of the dead miner's clothing upon a hook and the picture of the grandmother figure holding the newly orphaned child on her lap add further to the pathos of the scene. The total image is certainly significant as a piece of reportage that deals with the misfortune of a specific episode. However, on a more universal level, it also speaks in a blunt voice of protest against the exploitation of down-trodden people everywhere.

If any painting of the 20th century may be called the most powerful social outcry of the age to date that one work must be the *Guernica* of Pablo Picasso. The piece was painted in response to an event that took place in April of 1937.

General Francisco Franco was leading an army in revolt against the Spanish republican government of that time. To show the military strength he could command if he chose to do so he called upon his friend, Adolf Hitler, the German dictator to send a fleet of bombers to destroy a Spanish town. The target selected for the mission was the sleepy little city of Guernica. The armada came by one Monday afternoon and left the peaceful community completely smashed to smithereens. Franco had proven his point. Saturation bombing was shown to be very effective indeed for purposes of mass destruction. Not only were the buildings reduced to rubble but their inhabitants were also entirely annihilated in the process.

Picasso was outraged by such wanton obliteration of life and property. He had been asked to prepare a mural for the Spanish pavilion of the Paris World's Fair of 1937. With the violence wrought upon Guernica vividly in his mind he set to work on the painting that has become an unforgettable memorial to the battered old city and its residents.

The elements that make up the composition are symbolic rather than documentary. On the right, a woman with upraised arms cries out in agony as the flames in her home and her clothes combine to roast her alive. To her left, a half-nude figure looks out from the darkness in search of light. Surrounded by the holocaust her face expresses shock, dismay, and disbelief. All around her, the world is going to pieces and she is appalled by what she sees. Yet, she

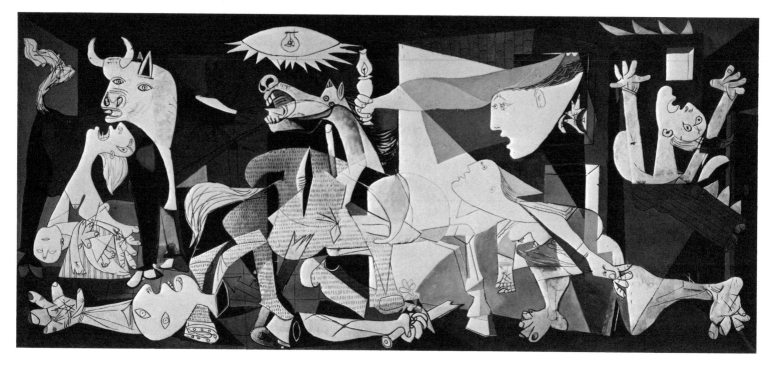

60 Pablo Picasso *Guernica* 1937, oil on canvas, on extended loan to the Museum of Modern Art, New York, from the artist. The violence visited upon a helpless Spanish town by Nazi bombers in 1937 is continuously commemorated by Picasso's powerful mural in black, white and gray.

cannot (will not?) accept what she sees. Directly above her a woman looks out of a window at the onrushing tide of events before her. Appropriately, she holds a *storm* lantern in one hand while her other hand is clasped in fear between her round and naked breasts. In the center of the mural there is a horse with head twisted about in pain, tongue stuck straight out, and teeth bleeding from the gums. A spear, hurled from above, like bombs sent downward from the sky, tears into the horse's back and comes out, sharply pointed, just above the lower abdomen. As a symbol of nobility in the face of adversity the horse is seen to be crumpling at the knees, straining to stay up but apparently doomed to collapse—perhaps never to rise again. Along the lower left edge of the canvas, the shattered fragments of a hollow statue of a warrior lie strewn about. The warrior's head is clearly severed from his body and in the clenched fist at the end of the fractured piece of arm we see a broken sword. Oddly, in that one detail, we also see the one touch of hope in the whole painting: a flower—standing upright, uninjured in the madness that is crashing all around the flower. Even more terrible than the sight of

the punctured horse and all the other victims on the right is the picture of the horror stricken mother on the left who screams out in terror and despair as she holds a limp, dead child with broken neck in her arms. Just above her, entirely insensitive and unmindful of her pain a pale headed bull with a dark gray body and swinging tail calmly looks around and away from all the misery so close at hand as though none of this is his concern and so he need not be troubled because, after all, these events are not *his* problem. And yet, immediately to his right, a bird—is it a dove of peace (?)—is about to fall down upon a table with its neck, like that of the dead infant child, broken. Above all the grim darkness a bulb shining bright, lights up the composition as though to say that everything pictured below is not fiction but fact. Like an all-seeing eye bearing testimony to *truth* the light bulb almost declares that it must be the inexorable fate of man to suffer cruelty, indifference, and inhumanity at the hands of his brothers as long as he places greater premium upon conquest and destruction than he does upon peace and constructive harmony.

The *Guernica* of Picasso reflects a profound depth of insight into the plight of war victims anywhere and everywhere. We find that our sensibilities are torn by the combination of poignancy and horror he has put together in his painting. With an astonishing economy of lines and tones, the over-all mural evokes our deepest compassion. So little has been used graphically to say so much. Very possibly, if more had been used, less would have been said.

Unfortunately, as a rule, the only people who respond to what the socially critical artist has to say are the very people who already agree with him even before they see his pictures. More often than not, those who are most in need of receiving the humanitarian message are totally blind to what art is all about. As a consequence, many of the most thoughtful and sensitive creative artists of our time have come to hold grave reservations about the power and effectiveness of didactic painting in the arena of mass communication.

14 | Post World War II–turning inward again

The social, political, and economic upheavals of the 1930's eventually culminated in World War II. Never before had the earth borne witness to such grand-scale hostility and devastation. It is almost as though Picasso's *Guernica* in 1937 had been an accurate prophecy of what was destined to break out in full fury upon the horizon of the whole world. After it did break, in 1939, the war soon reached out in all directions. By 1941 it had moved to the farthest corners of the globe.

Many painters who had believed that art should be an instrument of social criticism and reform felt that they had been mistaken in their assumptions and presumptions. While art may communicate, it can communicate only with people who are sufficiently familiar with the language of esthetic form employed by artists. Obviously, language above the level of a lowest common denominator (such as matchbook covers or billboard posters) loses more and more of a potentially massive audience as it goes beyond the banal and the obvious. Instead of picturing social realities artists increasingly began to search for the essence of reality which moved them most and was also appropriate to realization in paint and canvas. Taking their cue from *Dada, Surrealism,* the non-representational art of Kandinsky and others, they turned to the reality of their internal sensations. The step was very logical. After all, what is more real to anyone— and especially to an artist—than the feelings lodged deep within the recesses of his inner being?

During the war many of the world's great modern artists such as; Marc Chagall, Fernand Léger, Marcel Duchamp, Max Ernst, George Grosz, and Piet Mondrian left Europe and came to work in the United States. Without doubt, the presence of such creative

giants and their influence also played a very important role in the emergence of an approach to painting that was developed by certain young American artists during the war years and thereafter.

By 1945, with the end of World War II a very distinct, new direction took shape. An image unlike anything else before it appeared in the work of several painters who can be grouped together with the collective name: *Post World War II School of New York*. Frequently, they are also referred to as *Abstract Expressionists*. While the new movement owed many debts of gratitude to earlier artists it was also a breakaway from most of what had come before.

Foremost among the artists breaking ground in establishing the new school was Arshile Gorky. While one may identify the presence of forms that are reminiscent of shapes created in an earlier time by Picasso, Miro, and the Chilean Painter, Matta, Gorky's art is certainly his own. Above all else, his paintings have a rich feeling for elegant linear forms brought into relationship with grounds of varying registers of color.

Free flowing, liquified movements animate Gorky's compositions. This is probably the result of great *discipline* exerted for the purpose of letting the brush go to find its own way—guided more by intuitive impulse than intellectualized reason. Perhaps that sounds like a

61 Arshile Gorky *Agony* 1947, oil on canvas, collection, The Museum of Modern Art, New York (A. Conger Goodyear Fund). Free flowing forms seem to glide softly and silently into contact with each other only to then drift apart again.

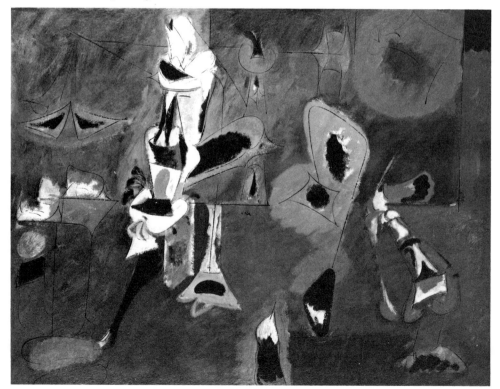

paradox. Frankly, it is. But, Gorky's art works that way. After all, painting need not necessarily be logical. Paintings are neither scientific truths that can be repeated in a laboratory nor mathematical theorems that can be proven. Art confirms and projects the universal realities of human experience in its own mysterious way.

In Gorky's mature work the edges of the forms glide gently, softly and silently into each other. Oddly enough, while they do slide, they are never slippery or slick. It is rather an uncanny sensitivity that connects the shapes. That sensitivity is very evident in the washes of color that have somehow become electrified with an internal spark of life. You feel the sheer power of the current as you thread your way from one passage to another. Figure and ground keep shifting back and forth and a given shape lends itself to an infinity of associations. In a mystical kind of way the forms suggest clouds, rivers, bodies, bones, stones, and human limbs of every description, and yet, they are also none of these things because they are what they are as fluidly runny washes of intermingling color that have an integrity and existence of their own.

Another of the artists who played a very important part in getting the new post-war movement underway was Robert Motherwell. His paintings were especially potent in their assertion of humanized feeling. The layers of paint and occasional collage elements that appear in his work make for a powerful impact upon the sensibilities of interested spectators.

What is it about Motherwell's art that holds up as well today as it first did in the years when *Abstract Expressionism* was an extremely avant-garde movement? Most likely, it is the sheer painterly richness of his work. The body of an area of black, for example, has a sense of *substance*. The surfaces are always alive with a resonance all their own. But there is more to it that that. As we noticed in the work of Gorky, the images put together by Motherwell function on several levels. First, there is the range of associations and references that are suggested by the shapes, colors, and textures put together in a given canvas. Take his ovals. They became heads, bodies, growing forms and so on. A sweep of tan is a sandy beach, a moving figure, or a hundred other possibilities. However, on another level, the work is what it is as an organization of form in itself—without reference to any associations outside the composition. Viewed in this context, a painting of his does not presume to be other than what it is—a work that is self-sufficient and independent of servitude to anything beyond its boundaries.

Besides the sense of independent totality, and in addition to the sheer substance of the paint or collage elements, Motherwell's art

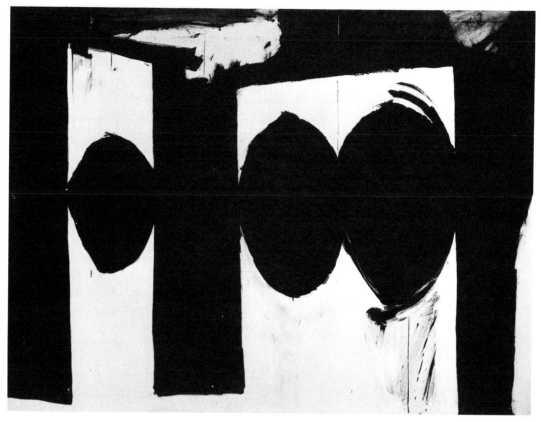

62 Robert Motherwell *Elegy to the Spanish Republic, 54* 1957–1961, oil on canvas, collection, The Museum of Modern Art (photograph by Rudolph Burckhardt). The sense of a total involvement between painter and painting is vividly evident in this work by Robert Motherwell.

manifests a passionate involvement between the painter and his canvas. You have to see the work to appreciate this. You look at it and if you are receptive to what is going on, you soon find yourself getting caught up in the active life of the forms. Of course, the forms are made of nothing more than lifeless paint, paper, and canvas. But, by the magic of some creative cunning, those once dead materials have become transformed. They have been turned into tensions and energies in flux—ambiguous currents that are true to themselves as form. Elusively, they defy translation into verbal language.

We should not overlook the fact that Motherwell has exercised considerable study to get to the point of being able to make his paintings. Those who want their art easy or instantaneous should look to comic strips, clever magazine covers, or slick book illustrations for visual amusement. Motherwell's art does not seek to

titillate viewers; it is only for those who would participate in an art experience in depth.

Mostly, the paintings of Motherwell come through as an art of personal poetry. On occasion, a work may be soft and lyrical. Golden passages of muted ochre, for example, may be tenderly and delicately placed beside patches of pale white. Sometimes his poetry raps out a nervous staccato. Harsh notes of black and white scrape against each other with an irritation that grinds across the grain of human sensibilities.

Sooner or later, some will ask, "What distinguishes Motherwell's art from the mere decoration, however handsome, of a wallpaper design, a necktie pattern, or a rug on the floor?" The difference lies in the profound human depth he manages to impart to his work. However, only those with a prepared readiness and interested willingness to acknowledge and respond to this mystical, physically unmeasurable quality will be able to identify it. While there is "design," for example, in some textile pattern as well as in a Motherwell painting there is a great divide between the mystical presence planted in the painting and the lack of a mystical presence in the textile, or other applied design object. In effect, the painting begins where the "design" ends; but, one must *know* the language of design to get near where the painting begins. Only then are you able to interact with a given composition and share in what it has to offer— share in the secrets that are private and yet also universal and therefore strangely public.

While the work of Gorky and Motherwell certainly had much in common, it was the uniqueness of their way of painting that gave the new movement its special appeal. With the passage of the years after the war one major figure after another contributed his singular way of seeing and speaking with paint. All together they built a school of expression that was buoyantly alive and rich with diversity.

15 | Pangs of feeling thrust forward in two directions

With the advent of *Abstract Expressionism* artists turned to all manner of unorthodox methods for creating form with paint. However, they were not motivated by the pursuit of mere novelty. Instead, they were interested in advancing a certain kind of expressive image; an image that was, above everything else, completely and uniquely personal.

Nevertheless, while considerable emphasis was indeed placed upon the uniqueness of an artist's individual expressional form, in retrospect, we find that two dominant sub-movements actually came into being within the over-all scope of *Abstract Expressionism*. The work of virtually all the artists associated with *Abstract Expressionism* tended to fit into either one or the other of those two categories. In the first group we find compositions that are endlessly agitated with feverish bursts of nervous energy. In the second we meet paintings that are hauntingly still and somehow, peacefully passive in their emotional tone.

The classic example of the first type consists of work created by Jackson Pollock, probably the best known of all the Action painters. Perhaps in over reaction to his early academic training Pollock developed a loose-limbed, free swinging style that is instantly recognizable as his style and his alone. But, it did not happen overnight. First, he went through a period in which the influences of Picasso and the Surrealist movement were very evident. Pollock was filled with a desperate longing to set his deepest feelings free into paint on canvas. Adapting a highly spontaneous approach to his brush-stroke his works of the late 1930's and early 40's appear as fluidly turbulent, abstract configurations. Bright and bouncy shapes, supercharged with

color, twist and turn every which way. But Pollock felt that something was still being held back. What he painted came from the wrist and finger manipulations of his brush. He longed to go further—to participate with his whole body in the painting process. The breakthrough came for him when he discarded brushes as the sole means of applying paint to a surface. Inventing an incredibly personal spatter-dash technique he used sticks dipped in liquefied paint to drip and splash skeins of writhing color across pieces of canvas he had prepared by rolling them out on the floor of his studio. No longer standing still before an easel he could throw every bit of his whole being—body, mind, and feelings—into the act of making a painting. Obviously, such a way of working resulted in patterns of paint that were markedly different from forms realized with wrist and digital movements of a brush touching a surface placed vertically on an easel. The random movements and chance overlapping of dripped color became swirling compositions filled with unprecedented measures of rhythm. By all rights, one might expect such a procedure to yield hideously haphazard effects. As a matter of fact, when others began to imitate Pollock they did often wind up with gross and slipshod inadequacies of all kinds. But, Pollock's work was something else. He had patiently learned to master the paint— his sensitive awareness and feeling for color and shape relationships disciplined what might otherwise have been a process seemingly fraught with recklessness and abandon.

In *Autumn Rhythm* we can see a good example of Pollock's high style at its best. You may enter the painting on any roller coaster track of paint you choose to begin with. Following along that line you zoom up, dive, curve around, fall suddenly, and twist about—out of one complex vortex of vision into another. With an almost irresistible force you are driven about the canvas—through whirlpools of richly built-up layers of paint. Pulsing without pause, your motion is accelerated through the maze, colliding with clot after clot of jeweled streaks in violet, silver, and black. What may have looked at first like a jumble soon reveals itself to be an amazingly ordered relationship of chromatically whirling lines in a white canvas ground. The longer you stay with the work the more you find that you are never thrown outside of the frame of reference defined by the four sides of the canvas field. Eventually, when you are ready to turn away and want to look at other things you find that contact with the Pollock painting stays with you. The restlessly active excitement free of cliché and reference to subject matter has occupied you and involved you so completely that you almost have to catch your breath before you can go on. In a world where there are all kinds

of easily understood mass communications we may stop to ask ourselves what is Pollock's painting "supposed to" communicate. Perhaps, with a sudden rush of awareness we realize that his message is not *about* something, somebody, or someplace outside the painted canvas at all. Instead, his work *is* something (created) and we have *become* the principal somebody—beside him—actively participating in the painting experience and wherever that experience takes place is the someplace that the painting is all about. In a whole new kind of way, a subjective reality (the painting) created by a powerfully passionate man becomes a community into which we may enter and from which we may then depart.

In addition to Pollock, there were other important Action painters who made their mark in the 1940's and 1950's. In particular, Hans Hofmann, Willem de Kooning, and Franz Kline stand out because their work was such a potent influence upon the thinking and development of great numbers of other painters.

63 Jackson Pollock *Autumn Rhythm* 1950, oil on canvas, The Metropolitan Museum of Art, George A. Hearn Fund, 1957. Swinging curves of color streak back and forth across the painting with a sense of nervous urgency.

64

66

65

Hofmann played an especially important role as a teacher as well as a painter. His art school in New York City, and during the summer months at Provincetown, Massachusetts, attracted students from far and wide. They came to him because they wanted to learn how they could achieve freedom in their creative work without sacrificing a sense of order. For countless numbers of aspiring painters Hofmann proved to be an inspiring model; his own paintings were a continuously growing body of tangible visual data that both illustrated and supported what he talked about in the studio classroom.

Willem de Kooning's style has probably been the most widely copied of all the action painters. His paint surfaces—fluently brought to realization with brush and knife—fired the imagination of followers from Capetown to London—from Tokyo to Honolulu and all the way back to New York City. The appeal of de Kooning's art grew out of an originality that generated awesome shock power and a remarkable sensitivity for creating subtle visual relationships between the most lacerated and fragmented of shapes and colors. In addition, his work throbs with a sense of excitement as fever-hot, split second decisions and changes made during the painting process have been documented in dramatic gestures of paint manipulation preserved for all of us to experience when we come close to his work.

The forms to be found in Franz Kline's canvases are packed with a potent sense of immediacy. As we look into his compositions we feel ourselves in touch with naked structure. Nothing is hidden. With raw energy, completely free of slickness, we are wrapped about with driving forms that have never gathered dust on a studio shelf—forms that are definitely not shopworn like most of the tiresome clichés and stereotyped image content we generally encounter when

64 Hans Hofmann *The Window* 1950, oil on gesso coated canvas, The Metropolitan Museum of Art, gift of Mr. and Mrs. Ron R. Neuberger, 1951. Though the tightly fused composition seems to burst with an explosive crash, the over-all design never violates the limits defined by the four borders of the canvas.

65 Willem de Kooning *Woman I* 1950–1952, oil on canvas, collection, The Museum of Modern Art, New York. Aggressively agitated strokes of paint have been used to construct a composition that is packed to its very edges with expressive power.

66 Franz Kline *Torches Mauve* 1960, oil on canvas, collection, Philadelphia Museum of Art (photograph by A. J. Wyatt, staff photographer). Raw energy comes tearing out of the paint with surging power in this canvas by Franz Kline.

67 Mark Rothko *Number 10* 1950, oil on canvas, collection, The Museum of Modern Art, New York, gift of Philip Johnson (photograph by Geoffrey Clements). Fluid passages of color lead us to discover states of awareness within ourselves, states we may never have suspected were always there but were previously unknown to us.

we go to see paintings by the more usual run-of-the-mill hack painters of our time.

By contrast with the work of the action painters the art of the *Quiet* Abstract Expressionists is gently muted and generally free of turbulent frenzy. Good examples of this side of the Abstract Expressionist movement may be found in the paintings of Mark Rothko, Barnett Newman, and Clifford Still. Their compositions, woven out of films of floating color open up universes of new experience for the inner spirit of a spectator. Of course, such experience is possible only for people who are willing to put preconceived prejudice entirely aside—willing to work with their nerve endings attentive and involved in the relationships created in color on canvas. The benefit that accrues to such effort is an expansion of awareness within the mind's eye of the person making the effort. In the art of the *Quiet* Abstract Expressionists the simplest of forms convey complexities of mystery which in turn open up internalized insights that reveal metaphysical truths which cannot be explained with words. By the same token, they cannot be arrived at with reference to any material objects.

Differences in color make for a shimmering richness of optical impact. Principally, those color differences determine the location of shapes in the flat, plane-space of the canvas surface. The design of a given painting meets us head-on. The simultaneous sense of flatness and spatial opening we find for example in a work by Rothko is both eerie and puzzling in its ambiguity. Background and foreground are consistently interchangeable. The void *behind* some figurative element is as active as the figure itself. What may at first look like it is in back of a particular element may seem to come forward as the shape that *was* forward is seen to recede and become a background. The reciprocal interplay of depth and flatness sets up tensions that infuse the paintings with a remarkable kind of internal vitality not readily apparent at first glance. The seeming simplicity is very deceptive and yet very essential. For practical purposes, they upset our comfortable equilibrium. Our boat, so to speak, gets rocked up and down as well as pitched from side to side and as a consequence we may pierce our way through to internalized insights we could not achieve any other way.

To be sure, *Abstract Expressionism* was a new vision. While it grew out of what had come before, it was no longer *like* what had come before. If we are not accustomed to looking at Abstract Expressionist works it is not a simple task to get what they have to give. It takes time and thought and above all else, patient concentration before we can feel the life inside the forms. If we look at examples of *Abstract Expressionism* and expect to be enjoyably amused, we are bound to be terribly disappointed. *Abstract Expressionism* proved to be a whole new land in the world of modern painting. Guideposts which may have been sufficient for earlier movements were no longer adequate to the task of pointing out where to go and what to look for in *Abstract Expressionism*. But, for those willing to make the effort that it takes, abstract expressionist works bring us a variety of experience like nothing else ever seen before.

16 | The continued pursuit of purity

While *Abstract Expressionism* was the center of attention in many avant-garde art circles following World War II, the artists who worked along the lines laid down by the Constructivists and De Stijl orientations also continued their particular development. This took place in spite of the fact that the "end of the line" was supposedly reached when Malevich painted the now famous *White on White*—in 1918. However, instead of being a blind alley with nowhere to go, pure plastic art has grown over the years to the point where today the mainstream has at least three well-defined branches. The first of these directions is chiefly concerned with creating a sense of order based upon pure design structure. This approach is exquisitely demonstrated by the work of Burgoyne Diller. The second path deals with the pursuit of mystical realities in pure form and may be seen in the paintings of Ad Reinhardt. The third direction centers on rich optical play and active retinal responsiveness. This tendency may be observed in the art of Josef Albers and Victor Vasarely.

His concern with order and structure became a consuming passion for Burgoyne Diller. When you consider how much Diller limited his work to very severe limitations of shape and color it is remarkable to see how diversified the structural quality of his efforts could be. The example titled *Second Theme* points out how much complexity there can be in a seemingly simple statement. Diller began the exploration of painting in pure horizontal-vertical relationships and primary colors in 1933. He continued to explore those potentials in two and three dimensions until his death in 1965.

For many years, the work of Ad Reinhardt has probably caused more consternation and provoked the sensibilities of more people interested in art than that of any other artist around.

68

69

68 Burgoyne Diller *Second Theme* 1937–1938, oil on canvas, The Metropolitan Museum of Art, George A. Hearn Fund, 1963. Upon continued examination, the deceptive simplicity of a Diller painting slowly reveals a considerable measure of discretely ordered complexity.

69 Ad Reinhardt *Abstract Painting* 1960–1961, oil on canvas, collection, The Museum of Modern Art, New York. The late works of Ad Reinhardt, like this example, were made to be objects of ultimate esthetic purity; all references to people, places, or things have been completely removed from the painted forms.

It is hard to be neutral about Reinhardt's work. You tend to react with either total favor or total rejection. After looking at his paintings, some people have suggested that Reinhardt has simplified his forms so absolutely that he has reached a *reductio ad absurdum*. They suggest that his paintings, though possibly sincere, are devoid of thought and feeling—that they add up to a little more than blank, formalized rituals with no particular esthetic or expressive significance. It is as though they are some sign of mourning at the graveside of modern art. Further, they maintain that the paintings become so tiresomely monotonous; that "When you have seen one, you have seen them all."

When Reinhardt's work as a painter is examined in retrospect, from before 1940 to the present, one sees an unfolding progression. That progression began with forms of "designed" geometric severity and proceeded to compositions based upon loose, irregular shapes and from there he went back again to very simple, non-contrived rectangular elements. By contrast with these changes, two charac-

teristics stand out continuously in his work across the years. First, each of his paintings appears to be a purely esthetic object. They are divorced entirely from the lead weight of life experiences. Any reference to events, people, things, or places was entirely removed from Reinhardt's paint surfaces. On the other side of the canvas— in the world of human society Reinhardt was deeply committed to such fundamental principles as peace, justice, equality, and decency. However, he did not subscribe to the notion that making pictures of desperate or corrupted circumstances or dehumanized people proved his sympathetic concerns for people. Instead, he participated directly and actively in social matters without exploiting his paintings for propaganda purposes. The second characteristic that stands out sharply in Reinhardt's art was his will to be at the very forefront of the *avant-garde*; a will to bring forms into being that would take the art of painting forward without perpetuating the past. Reinhardt's work was therefore a kind of "ultimate" step.

In his last work, before his death in 1968, Reinhardt left behind the tricky, entertaining textures and sensuous colors of his former periods. Instead, he developed a non-decorative approach that was free of novel brushwork and unusual, off-beat design relationships.

Those last paintings are virtually non-verbalizable. The more you try to talk about them, the further you are removed from what takes place in the paintings. Because the canvases are not really black, but rather *very, very* dark values or tones of reds and blues and other colors, no black and white reproduction can possibly suggest the radiant energies that glow and interact with each other upon the satin surface of those canvases.

Any plastic-visual art, almost by definition, must make some impact upon a spectator's retina. What distinguishes the work of people like Vasarely and Albers is the very high degree of retinal impact generated and sustained by the forms they have brought into being.

In Vasarely's work optical illusions occur because there is a gulf between our perceptual judgment and the actual physical being of his paints on a surface. He achieves flickering movement and dazzling color effects by a very sophisticated and creative use of interrupted sequence systems, figure-ground oscillations, brightness contrasts, and after images.

Few artists have maintained the consistency of qualitative output that has been achieved by Josef Albers during his long and fruitful life. Because he has been an outstanding art teacher as well as an artist, Albers has exerted a double-barreled force upon both art education and art.

In his work Albers has continuously sought a maximum measure

70

70 Victor Vasarely *Kiu Siu* 1964, collection, Philadelphia Museum of Art (photograph by A. J. Wyatt, staff photographer). Figure-ground oscillations and variations in brightness give Vasarely's patterns a feeling of movement without end.

71 Josef Albers *Homage to the Square: It Seems* 1963, oil on board, collection, Philadelphia Museum of Art (photograph by A. J. Wyatt, staff photographer). The major focus of Albers' art centers on the interactions taking place between the color areas that are situated beside and within each other in his paintings.

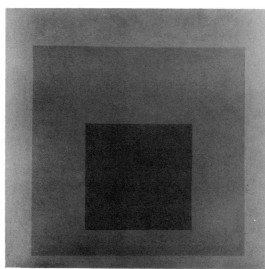

71

of simplicity in combination with a minimum of means. He has thus produced a modern "classic" art form. His central concern has always been with the interactions that take place between color-shapes situated beside and within each other. In the process, space has become a living reality in his art. That space is utterly uncanny; in no way does it resemble natural space. While the forms he uses are as concrete as they can be, the space sensations they project are weirdly ambiguous. Depending upon how you see them they may seem to pop out from the surface and also tunnel in deeply to somewhere beyond infinity.

Albers' paintings are not cold, mechanical, or monotonously similar. Animated from within their structure, the forms are moving and breathing layers of pigment with a life all their own. In some instances, they quiver and pulsate; in other instances they become muted and serene or else—entirely silent. Each one demands a separate frame of mind for feeling what it has to say.

Why does Albers' art function as well as it does? Perhaps it is because sighted people are endowed with the ability to see. We can

therefore respond to what the colors and shapes do with each other in his work. If we had no critical sense of sight, Albers' art would be empty and meaningless for us.

Contrary to a common misunderstanding, the artists who follow the path of working in pure, plastic form are not necessarily concerned with mathematics or science. Even when they seem to proceed like programmed computers, more often than not, they are actually involved with the forms of purity for mystical, lyrical, or spiritual purposes. When it looks like they are following tight, dehumanized, and systematic rules, they are actually in the midst of uncovering ways of working that are uniquely suited to their individual and most deeply personal temperaments. What could be more human?

17 | Cool art—closing the gap between the studio and spectator

Which way should an artist turn? Shall he preserve the esthetics of the past or carve a new road into the future? The choices must be made. The artist has to decide which direction he will take. Whether he likes it or not, his work will reflect his choice: to look backward, stand still, or move ahead.

One of the strongest currents flowing forward in the recent stream of abstract art is generally referred to as the *Cool* movement. All sorts of other names have been proposed—like *Minimal, Simplistic,* and *Primary*—but none has stuck as well and as long as *Cool*.

The heralds of the *Cool* outlook were the painters: Josef Albers, Barnett Newman, Ad Reinhardt, and Mark Rothko. Their approach to painting in the late 1940's and the 1950's was diametrically opposed to Action Painting, the school that was so popular during the years that followed World War II. Because Action Painting seemed to whip up such a froth of heat, the kind of image that was most contrary to Action Painting quite naturally came to be called: *Cool Art*.

Stated very briefly, the fathers of *Cool Art* sought to set themselves free—esthetically free of servitude to outmoded imagery. Refusing to make art based upon personal hysteria, myths from the past, or the general life of contemporary man they created forms from out of their own unique, internal necessity—forms that were not bogged down by extra-art associations.

72 Leon Berkowitz *Corona Number 7* 1968, Acrylic on canvas, The Aldrich Museum of Contemporary Art, Ridgefield, Connecticut. Rather than look back to the past, Berkowitz aims to make progress with the continuing evolution of modern painting.

73 David Diao *Untitled* 1968, acrylic on canvas, The Aldrich Museum of Contemporary Art, Ridgefield, Connecticut. The most subtle of sensations rest just beneath the surface of Diao's work.

74 Ellsworth Kelly *Blue-Green* 1961, oil on canvas, The Aldrich Museum of Contemporary Art, Ridgefield, Connecticut (photograph by Richard Di Liberto). Kelly's painting invites our response to the color-forms he has crisply rendered upon the canvas.

75 Robert Swain *Second Triangle* 1968, Acrylic on cotton duck, photograph courtesy of the Fishbach Gallery, New York. A composition of non-representational forms is able to carry on a life of its own—free of servitude to outworn cliches and tiresome subject matter references.

In the introduction of a catalog for an exhibition at The Aldrich Museum of Contemporary Art in Ridgefield, Connecticut, from January to March of 1968, Larry Aldrich succinctly, yet quite accurately, described *Cool Art* as, "that art which specifically embraces space, science, and technology. It is impersonal, sophisticated, intellectual, non-illusory, monumental, classical, reductive, simplified, objective, direct, elegant, calculated, non-arty, nuance-full, and has intense physicality."

In the best of *Cool Art*, puzzles about the content of some iconography or other are entirely eliminated. For example, in a given work, there is no problem about what is supposed to be represented since there is no subject matter being represented. Consequently, the issue becomes: What do you make of it visually and how do you go about looking into the work? As spectator, *you* must invent a structure of relationships to bring to the art experience. To just sit back, waiting to be entertained or amused is to completely miss any potential experience.

Obviously then, *Cool Art* is rather demanding. You get little from it if you go up to it passively. You have to cut through the haze of your own indifference. Your resources for searching, asking questions, seeing, thinking, and feeling all have to work actively in the process of looking into *Cool Art*. If you can do all of that, the pulse of the form within the seemingly cool, detached art object can beat with movement and become alive inside of you.

Through his art object, the *Cool* artist invites a new measure of audience involvement—including audience participation in the creative art process itself. No longer does he operate exclusive of his audience, even though he may still make the work by himself (or have it made by others—in a factory—from his plans.) In either case, his pieces invite those of us outside his studio to share in the working problems and frustrations. But, we also join him in the sense of triumph he accomplishes when a significant breakthrough is made and he expands the previous limits of his art experience. As the horizons of his vision are extended, so too is ours.

Cool Art has made it possible for us to feel subtle sensations and new stages of awareness. In contact with *Cool* forms we may find ourselves brought to the brink of the ineffable. No words adequate enough to illuminate the experience have yet been strung together sufficiently well to explain how it all works or what it feels like. So far, only the language of vision can effectively tell it as it is.

18 | Remember Dada?
Today we call him Pop.

Remember Dada? Who can forget Dada? More a frame of mind than an art movement, Dada was full of method as well as madness. From 1915 to the early 1920's, Dada provided a bridge where abstraction and the school of German *Expressionism* could meet. In time, it was followed by *Surrealism* and still later, by *Abstract Expressionism*.

Much of Dada was pretty bad. It was so negative. Dada was against almost everything from life in general to art in particular; little matter whether the art was traditional or modern. Dada was a frantic shriek of rebellion against war, against the society that made war possible, and against the art that was a product of that society. By 1923 Dada wound up even being against itself. Nevertheless, in spite of being self-destructive, and therefore short-lived, such Dada works as the chance reliefs and freeform sculptures of Jean Arp, the collages of Kurt Schwitters, and the trenchant visual puns of Marcel Duchamp have held up exceptionally well over the years. While much Dada art is now forgotten, the solid achievements of Arp, Schwitters, and Duchamp continue to command interest and respect because of their intrinsic esthetic vigor and expressive power.

Perhaps the best current parallel to Dada is *Pop art*. As Dada grew out of what it was partly against (abstraction and *Expressionism*), so too, Pop is both a by-product of and a rebellion against *Abstract Expressionism*.

In the late 1940's and early 1950's, the river of *Abstract Expressionism* was a raging torrent. Eventually it ran dry. The most virile "action" painters of the movement: Jackson Pollock and Franz Kline, quite literally, died. Those who remained lost their cutting

edges. Willem de Kooning, Adolph Gottlieb, and Mark Rothko, to name a few, developed an almost effete decorativeness. By the 1960's their work tended toward a repetition of tiresome, self-centered signature images.

The path leading away from *Abstract Expressionism* toward a new direction was provided by Robert Rauschenberg and Jasper Johns. Into paint surfaces oozing with slippery patches of color, Rauschenberg introduced such odd, interesting, and clearly recognizable objects as clocks, radios, and automobile tires. These combinations of juicy areas of paint and real objects were called: *combine-paintings*. In a combine-painting the created reality of pigment on canvas is supplemented by the reality of objects from the world outside of the canvas. In other pieces of work Rauschenberg combined images from many different sources into a flat montage. Pictures of objects and events that were normally remote from each other in time and space were joined together, artfully, in Rauschenberg montages. Like Rauschenberg, Johns has also sought to bridge the gap between

76 Jasper Johns *Target with Plaster Casts* 1955, encaustic on canvas with plaster casts, collection, Leo Castelli, New York (photograph by Rudolph Burckhardt). Commonplace objects treated in a painterly fashion by a genuinely sensitive artist cease to be humdrum objects and become parts of an esthetically significant work.

77 Robert Rauschenberg *Navigator* 1962, combine painting, courtesy, Leo Castelli Gallery, New York (photograph by Rudolph Burckhardt). In the combine paintings of Robert Rauschenberg the created reality of pigment on canvas is supplemented by the reality of fragments from the world outside of the canvas.

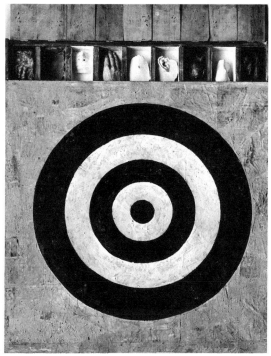

76

77

art form on the one hand and non-art on the other. For example, Johns has taken such commonplace objects as target shapes, plaster castings, flag forms, stenciled numbers, or empty beer cans and decorated them in such a "painterly" manner that they ceased to be ordinary humdrum objects and became esthetically significant—not because of what they were to begin with but rather because of what an "artist" can do with raw material. Instead of merely being visual novelties, Johns' work manages to profoundly probe such eternal philosophical questions as: What is real; What is illusion; and are things what they seem to be?

Perhaps the movement that followed the efforts of Rauschenberg and Johns should have been called: *The New Realism*. Instead it became *Pop art* because, in large measure, the artists who comprise the movement turn to "popular culture" for their visual vocabulary. The specific term: *Pop* was initially coined by Lawrence Alloway, an English art critic. Typical sources for the expressive language of Pop artists have been: comic strips, press photographs, store window display ideas, package labels, and advertisements.

The perspective provided by a Pop artist is quite different from that of the Abstract Expressionist. In the earlier movement, forms were the product of an urgently compulsive, internal necessity. By contrast, the image projected by the Pop eye tends to look externalized and detached as it confronts various aspects of the surrounding commercial, social, or industrial landscape.

Generally speaking, the Pop-outlook on contemporary society has two sides. The first one is essentially satirical. The most banal and vulgar examples of fine art, commercial art, or life at large are given broad burlesque treatment. Soup can labels for example have been magnified and rendered in black and in hot fluorescent colors by Andy Warhol. Wesselman's "great American nudes" have all the chic coolness of mannequins in a department store window display. The plaster hamburgers of Claes Oldenburg are big, bright, and colorful. They are also very unedible. The other side of the Pop-outlook consists of discovering unexpected potentials for esthetic interpretation in subject matter generally thought to be inappropriate for such purposes. For example, Warhol's colors do come alive with surprising vitality. Wesselman's work does present remarkably rich tactile qualities. The enamels smeared across Oldenburg's hamburgers have all of the jolt and sense of movement that can be felt in a painting by Jackson Pollock.

Compared with semi-representational or non-representational art, Pop art seems to look "easy". People who otherwise claim they know little about art often say they "understand" Pop art because

78 Andy Warhol *100 Cans* 1962, oil on canvas, Albright-Knox Art Gallery, Buffalo, New York (gift of Seymour H. Knox). Virtually every visual statement by Andy Warhol manages to command a spectator's attention even though the very means of obtaining that attention may cause fatigue to set in shortly thereafter.

79 Claes Oldenburg *Two Cheeseburgers with Everything* (*Dual Hamburgers*) 1962, burlap soaked in plaster, painted with enamel on a painted wood base, collection, The Museum of Modern Art, New York. Philip Johnson Fund, 1962 (photograph by Soichi Sunami). The plaster hamburgers of Claes Oldenburg are delightfully bright, colorful, appealing, and utterly inedible because they are a satire on commercial art and not really hamburgers at all.

78

79

80 James Rosenquist *Car Touch* 1966, oil on canvas, collection, Galerie Ileana Sonnabend, Paris. (Photograph by Rudolph Burckhardt). Like a magnifying glass, Rosenquist's painting provides a sharp, close-up view of details from the world around us.

81 Roy Lichtenstein *"Sweet Dreams, Baby!"* 1965, silkscreen on paper, courtesy, Leo Castelli Gallery, New York (photograph by Rudolph Burckhardt). Many different levels of insight and personal response are stimulated by the interplay of smooth and ragged shapes often found in pictures by Roy Lichtenstein.

the subject matter usually appears to be self-evident. Perhaps that accounts for the widespread acceptance and popularity of Pop art. In most Pop art, the subject matter is mundane. As a consequence, because the images are apparently obvious, it takes real effort to find what is significant in the work beyond the mere representation of trivial subject matter. For example, in a Lichtenstein painting based upon a comic strip panel you have to look beyond the crude slickness and impersonal, overly exaggerated picture. What matters is not simply the source of Lichtenstein's forms but the impact of his painting and the total response of our feelings and thoughts as they interact with each other on many levels inside ourselves. We can get caught up in the interplay of Lichtenstein's shapes—some of

82 Roy Lichtenstein *George Washington* 1962, oil on canvas, collection, Mr. and Mrs. Leo Castelli (photograph by Eric Pollitzer). Lichtenstein frequently gives us cause to consider how very much we may be deeply affected by supposedly bland and impersonal pictures.

which are raw and ragged while others are smooth; in the sweeps and turns of movement within the composition; and in the counterpoint of contrasting blacks, whites or other colors in flat areas and polka dotted patterns. The polka dots in various colors bring us into close touch with the feel of enormously magnified halftone screen dots. They are the dots we find when we look closely at pictures printed in newspapers and magazines. Soon we find ourselves contemplating the miles and miles of printed pictures to which we are regularly overexposed.

Lichtenstein's paintings give us cause to consider how those bland, impersonal, and supposedly detached pictures actually do affect people. Perhaps we come to see how those millions of big and little pictures that surround us, whether they have been projected electronically on TV screens or printed on presses, interest us, provoke us, and even move us. Possibly with some sense of shock we come to see how those pictures do indeed push people to become amused, attentive, and even *sold* on the purchase of consumer products, the acceptance of political ideologies, or what not. Lichtenstein's art is part of a tradition in which artists are concerned with examining the character and quality of human experience in society. Again and again, the paintings of Lichtenstein, James Rosenquist, and Robert Indiana present ironic commentaries on the ugliness and barren nature of much advertising and editorial art and the industrialized world that "uses" such "art" in billboard posters, TV commercials, illustration, signs, and comic strips. Implicit in many of their paintings is an image of contemporary man caught in a mass-oriented culture, devoid of personal identity, and constantly covering himself somehow to hide from himself the tensions tearing him apart from within the envelope of his skin.

Usually, when we glance across our social landscape the picture is vague and undifferentiated. There is so much to see and we don't quite know what to look at first. The Pop artist provides us with a focus. His work is a magnifying glass that affords a sharp, close-up view of fine details. It is like getting into a corner of the world pictured in a *genre* painting and then getting an awful lot nearer to a significant element within the over-all setting. The extreme closeness contributes an uncanny degree of intensity to the whole experience. Instead of responding with gross sensations our perceptions

become more specific and more poignantly sensitive. Here is an example. Not until the 20th century have people had access to so many goods and services that are machine-made. In pictures of wrappers on tin cans that enclose food (like Campbell's Soup) Andy Warhol directs our attention to industries that are certainly as much concerned with the container they sell as with the product it contains. By selecting such symbols of contemporary society with their wide range of meanings and changing them into art objects, Warhol helps us become sensitive again to forms which have lost their visual identity because of our super-saturated familiarity with them. He reminds us how conscious feelings have become *unfeelings*. We are invited to take a new look at things we know well but we see them uprooted from their familiar contexts. As we pause and examine what we see we may reflect upon the meaning of life in a world where greater premium is often placed on materialistic values than upon human or spiritual considerations.

What happens when we look at Warhol's "Brillo" sculptures? To take a wooden box, paint it the color of a cardboard carton and then silk screen a replica of what usually appears on the outside is certainly a brazen act. It is incisive and penetrating. It almost rips through you like a pair of rusty scissors. Why? Because Warhol lays that hideous package at your feet and thus confronts you with a fact of life in your world. You are brought into a direct confrontation with unrelieved ugliness. It is like when the German Expressionists at the turn of the century discarded pretty and "artistic" forms in favor of slashing brush strokes and blunt color for the sake of exposing and revealing the state of the *Human Condition* and the inevitable tragedy and pain that must be experienced by thoughtful and sensitive people in a world filled with thoughtlessness and insensitivity.

The endless repetition of the same image, whether they be Coca Cola bottles or pictures of well-known personalities tells us a great deal about our world as it really is. How much that surrounds us is as grimy and gritty as the coarse impressions printed on canvas with ink squeezed through photo-silk screen stencils? Certainly, they are not beautiful. But then, wide-scale advertising and the systems of mass production that stifle us by their harshness and dreary repetition are not beautiful either.

Warhol's work also speaks to us regarding our attitudes toward

83 Andy Warhol *Brillo* 1964, painted wood, courtesy, Leo Castelli Gallery, New York (photograph by Rudolph Burckhardt). The painted *Brillo* "put-on" a wooden box (which is very different from the cardboard carton it represents) points out with stunning clarity and colorful power how so much of our culture is extremely garish and appallingly empty.

84 Andy Warhol *Marilyn Monroe* 1962, silk screen enamel on canvas, courtesy, Leo Castelli Gallery, New York (photograph by Eric Pollitzer). The continuous repetition of an image, from row to row to row, causes our feelings to eventually become desensitized just as the endless repetitions we see and hear in our society induce anesthesia, which blunts our unique capacity to see and feel with intensity.

85 James Rosenquist *Pad* 1964, oil on canvas collection, Galerie Ileana Sonnabend, Paris (photograph by Rudolph Burckhardt). Several familiar but otherwise unrelated fragments are shown to actually have more than a few common denominators of visual appearance.

art. He questions our most cherished, preconceived expectations of a painting or sculpture. Originality that is self-centered, novelty as an end in itself, and sentimental reverence for preciousness are all hit quite hard. Maybe the air of the art world will be a little fresher because of his efforts.

There is quite a challenge involved in trying to make art out of the commonplace. It can be done and indeed, has been done—in the past as well as in the present. For example there were the marvelous still lifes of the most prosaic objects that were painted by Jean-Batiste Chardin in the 18th century and there were the amazingly fresh, inventive compositions of traditional, dull still-life materials painted at the beginning of the 20th century by the early Cubists. On the other hand, the Pop artist may fail to transform his subject

86 Jasper Johns *Small Map* 1962, oil on board, collection, Mrs. Leo Castelli (photograph by Rudoplh Burckhardt). Upon a foundation of shapes drawn from a map of the United States, Jasper Johns has built up a composition rich in painterly values.

matter. In that event, instead of art, he is simply left with sterile trivia—which is what happened to so many of the people who were associated with the Dada movement.

It is important to realize that as a movement, Pop is neither good nor bad. Pop may burn itself out because it is unable to consistently rise above the banal level of the "kitsch culture" from which it borrows so many of its forms. However, it is just as possible for the Pop movement to deepen, grow, and take on increasingly significant sociological overtones. It is possible that the Pop movement could develop a new naiveté of such brilliance that it could equal or even surpass the accomplishments of typical "primitives" from the past like Edward Hicks or Henri Rousseau. In the 1870's, how many people believed that Impressionism would grow into the movements that followed? Pop may also evolve into a new stage of development as yet unforeseen and still unforeseeable. Then again . . . it may not.

19 | Can electricity and art equal energy in form?

All of us live close to machines. Hardly anyone in our country can say his life has not been touched in countless ways by electricity. Yet we rarely think of machines and electricity as reservoirs filled with high potentials of esthetic energy. By contrast, some artists have come to see what the rest of us may not have noticed. By the magic of their creative vision they may be able to help us see what we have missed even though it surrounds us on all sides.

An awareness of light and motion is fundamental to our perception of the relationships between the earth, the moon, the sun, and the rest of the universe. Closer at hand we are constantly affected by miracles of motion and light that have been made possible by modern electronics. There are connections between these widely spaced realities. Perhaps, some of the new electric art provides a bridge across that space. Maybe it is taking place simultaneously with the re-creation of a whole new language of form appropriate to expressing our experience in the here and now—experience that is different in many ways from anything ever known or felt before.

Like anything else, a language grows stale and tiresome without recreation. Who is better qualified for the task of recreating the language of vision than the artist? Unfortunately, the forms one meets in the new electric art do not lend themselves too well to still reproduction in monochrome. These photoes and these words barely hint at what you can actually feel when you get close to the work. All that can be done here is to provide a little introduction. Beyond

87 Stephen Antonakos *White Hanging Neon* 1966, neon and metal, collection, Milwaukee Art Center (photograph courtesy of the Fishbach Gallery, New York). In a handsome splurge of multi-directional movements our vision rockets back and forth in tune with the cool glow of neon lights.

that you must go out, look up some of the new things, and see for yourself.

Making art is a process of transforming dreams into realities. Ideas zipping around the middle of an artist's brain become actualized outside of his skin when he shapes materials into expressive forms of his own invention. Must his dreams be limited to realization with materials from the past? Suppose he dreams of color intensities that no pigment in paint makes possible. Should he stop dreaming or should he search for materials that *do* provide the intensities of color that pigment in paint will not? Go a step further. How about color intensities in motion? It is not impossible. Some artists have already made the breakthrough.

The use of electric current as an art material does present a good share of problems. For example, one needs to know quite a bit about electricity—about things like circuits, switches, nuts, and volts. It can also be rather expensive—what with wiring, transformers, programming, and so on. And then, everything can hang on a fuse that will go and blow when it shouldn't but it does; or else a switch may burn out, or a power failure in town can completely dim out a masterpiece. It is an old story. Artists always have headaches of one kind or another. Glazes craze, paint layers crack, and colors have been known to fade.

On the other hand, electrically actuated art can open up all kinds of fascinating new possibilities. Esthetic thought and action may become liberated as they have never been let loose before. Think of the range of variations that can be explored two-dimensionally and three-dimensionally. Consider further what may take place four-dimensionally as image modifications unfold during a passage of time.

Naturally, the employment of electrically operated gadgets can become silly as well as trivial. After all is said and done, the hard questions always remain. For example, where do the fun and games end and seriously significant expression begin? Clearly, there is a

88 Les Levine *Iris* 1968, three television cameras wired to a system which actuates six television monitor screens, collection, Mr. and Mrs. Robert Kardon, Philadelphia, Pennsylvania (photograph courtesy of the artist). The picture shows Les Levine looking at *Iris* and *Iris*, in turn, looking back at him and showing the artist in a variety of views all at one time.

89 Dan Flavin *Three Sets of Tangented Arcs in Daylight and Cool White (to Jenny and Ira Licht)* 1969, daylight and cool white fluorescent light. From an installation included in a retrospective exhibition of the artist's work held in 1969 at the National Gallery of Canada in Ottawa (photograph courtesy of the Dwan Gallery, New York).

90 Stanley Landsman *Dante* 1967, mixed media, courtesy, Leo Castelli Gallery (photograph by Eric Pollitzer). The use of electric current has opened up a range of new possibilities waiting to be explored by creative artists.

91 Earl Reiback *Lumia Aurora* 1967, box with translucent screen and light energized by electricity, collection, Worcester Art Museum, Massachusetts. The photograph shows one point in an evolving light pattern that undergoes continuous change in its movements and shape relationships.

need for defining the components of quality in an art statement as new media are introduced.

In dealing with art forms tied up with buttons, buzzers, and flashing lights we must ask if our technology has outstripped our humanity. We begin to wonder if we live in a computer directed jungle. If we do not live there yet, we must inquire whether we wish to move into such a new neighborhood. Perhaps the move is inevitable. Then, may the new work become a way to mediate between our internal biology and the external realities presented by an electronically driven environment? Obviously, there is much here to think about.

There is no end to the questions. They must be asked because they are important. They are tied to problems that have come up in every new day and age. Can we accept the challenges presented by today's new wave of electric current art? Do we recall how the Impressionsits, van Gogh, Gauguin, Cezanne, the Fauves, and the early Cubists were greeted with rebuff and ridicule from the academicians and the art critics of the late 19th and early 20th centuries? Shall we, too, fail to *see* and accept the genuinely creative art of our own time in history? Certainly, this new art is not quite like any art of the past. But then, the times we live in and the materials now available to us for creative effort are not like anything we ever knew before.

One point is certain. Any new art is not likely to be understood all at once. It takes time, just as learning about anything worthwhile must take time. Learning is a gradual process. Familiarity comes slowly, by degrees. Little waves of contact need to roll in, again and again, in order to wash away the veil of unfamiliarity. Only then may flickering flashes of insight begin to build upon each other. With the accumulation of interests and information a pattern of understanding may take shape and become visible. That can occur only after the separate insights, like tesserae in a mosaic, fuse together into a grand, over-all whole. But first, before anything can happen, we must be willing to open our minds and air out our senses. If a hardening of our esthetic arteries has already taken place we may be so jaded and blind that we simply refuse to see what artists today are trying to bring to our attention. If that is the case, who else but ourselves do we then deprive of potentially rich new esthetic experiences?

20 | Off the wall and into space—the dimensionally shaped painting

The creative painter is too restless to ever be content with what he has already achieved. He must always be looking for ways to extend the present limits of his craft.

Two of the most obvious limitations that have traditionally kept painters hemmed in are the flat surface and the usual rectangular framing edges of a canvas or other support for painting. In the 1960's, a number of artists began to seriously explore possibilities for moving out beyond the limits imposed by these two long standing facts of studio life.

For many spectators and even other painters, the daring exhibited by artists who are exploring a shaped surface is somewhat perplexing and sometimes frightening. Regrettably, all of the old clichés are dragged out in self-defense. For example, one hears the argument that these new works destroy the very definitions of what a painting is supposed to be; that they are therefore only decorative novelties and not really art to be taken seriously as a medium for the expression of specific human concerns or human experience in general. Somehow, it all sounds rather like the broadsides issued by the old guard whenever the creative painter has broken new ground throughout the past hundred years of creative activity in the arts.

Actually, the idea of dealing with a surface that is not entirely flat and/or rectangular is not really new at all. The Cubists started it all with the introduction of collage elements many, many years ago. The Dada artists and the Constructivists went even further in the development of dimensional surfaces and liberated frames of reference.

However, the important point is that creative artists always *have to* abandon time-honored techniques and concepts when such tech-

92 Sven Lukin *Return* 1968, enamel on wood, The Aldrich Museum of Contemporary Art, Ridgefield, Connecticut (photograph by Ferdinand Boesch). Keeping within the bounds of a traditional rectangular format would have prevented Sven Lukin from creating the remarkably animated grace he has achieved with this particular piece of work.

93 Norma-Jean Squires *Kinetic Construction: Red, White, and Blue* 1969, wood, hyplar medium, and motors; photograph courtesy East Hampton Gallery, New York. Whole new worlds of experience are unfolded when the vertical volumes are set into motion and they turn about continuously in space.

niques and concepts are no longer emotionally or intellectually adequate to their needs. More often than not, those needs are felt intuitively. As the creature of impulse and compulsion that he is, the thoughtful creative artist seeks to bring his intuitively perceived sensations to realization in material and in form. Later, other people may come to feel what the form is about and some may even provide a verbal rationale that validly illuminates what the forms have to say in the language of shapes, textures, and color.

Because of the new tendency to explore the potentialities of shaped surfaces the clear-cut line that once separated painting and sculpture has become rather vague and uncertain. A variety of colors, applied

94

94 Harvey Quaytman *M. Thonnet's Tonic* 1968–1969, acrylic, photograph courtesy of Paula Cooper, New York (photograph by Eric Pollitzer). Whether or not a piece of work becomes relevant for a spectator may depend upon his willingness (and ability) to involve himself in the dynamics of that art object.

95 Lee Bontecu *Untitled* 1966, mixed media, collection, Leo Castelli Gallery, New York (photograph by Rudolph Burckhardt). In a dimensionally-shaped work a complex of surfaces appears before us instead of the more familiar flat plane.

96 97

96 Robert Mangold *X Series Central Diagonal IA* 1968, acrylic on masonite, collection, The Aldrich Museum of Contemporary Art, Ridgefield, Connecticut (photograph courtesy Fishbach Gallery, New York). Subtle differences between a series of wedge shaped forms add up to a fascinating composition.

97 Frank Stella *Ouray* (Sketch) 1962, copper paint on canvas; collection, Mr. and Mrs. Leo Castelli, New York (photograph by Rudolph Burckhardt). The strong striped pattern asserts itself with a silent dignity and enormously commanding power.

by brush, spray gun, or inherent in the structuring materials themselves are becoming a commonplace in the making of distinctly three-dimensional forms. By the same token, painting appears to be more and more dimensionally oriented than it ever was in the past.

In some ways, painters are bumping into more trouble than they ever would have expected as they became involved with the making of shaped paintings. First, they find themselves walking a tightrope between the world of two-dimensional figuration and the universe of three-dimensional form. Second, they are treading a path toward all sorts of technical difficulties. The physical complications of making something in three dimensions—not to even mention problems of storage, breakage, and transit—suddenly present awesome pitfalls to a painter. He may never even have known they existed until he gets into the mechanics of actually structuring, moving, showing, and preserving his new work.

As a canvas turns into a complex of surfaces rather than a flat field and as the frame of reference ceases to be a neutral rectangle or other simple plane geometric figure it soon becomes an *active* partici-

pant within its environment. The previously unoccupied (empty) space between painting and painter or painting and spectator fills up with a form-color tangibility that is quite impossible to avoid. Maybe the day of the painting—leaning passively against a wall—is in process of coming to an end. Once again, the creative painter may well be turning the handle of a door that leads to new pathways of art experience.

A central aspect of the shaped painting is the way it demands *engagement* if it is to be at all meaningful in a spectator's unfolding experience. The relevance of the work is vested in the relationship between the esthetic forms of the object and the response to them provided by a spectator. It is not so much subject matter, nonsubject matter, or even the materials employed in creating the object that make the critical difference in the potential art experience. Rather, it is the forms and the way they are totally perceived by an interested spectator that add up to participation in a unique kind of event. Naturally, only those who are capable of bringing an adequate frame of mind and an open, receptive emotional attitude may share in such an experience. To be sure, these new objects are not actually like any art from the past, regardless of possible forerunners that have preceded them. Therefore, to interpose preconceived expectations upon the work, especially expectations that may have nothing whatsoever to do with the forms in the work, is to prevent any responsive act from taking place since a condition of denial has been established which then serves to block any further contact and development.

The dimensionally structured painting presents a reality in space that is very clear-cut and unyielding. There can be no confusion about the environmental presence of such a work. The existence in natural space is no make-believe illusion meant to fool anyone's eyes. In effect, the environmental art object invites spectator interaction on a very tangible level of experience. Such a piece of work has the matter-of-fact existence in a spectator's world that old-fashioned paintings never had because they were, inevitably, in retreat from the *real*, three-dimensional environment shaped and framed by natural space. And yet, the shaped painting has a mystique all its own. After all, it thrusts a special kind of image content into the natural space where human life goes on. It is not a picture of what we are accustomed to seeing in our natural space. And so, when we make close contact with this new work our comfortable equilibrium is suddenly thrown off balance. We have to adjust ourselves to the thrust of the intrusion. Of course, we can just pass it all by—or we can become filled with wonder, concern, and consuming passion to

98

99

98 Robert Morris *Untitled* 1968, felt; collection, Gordon Locksley, photo-
graph courtesy Leo Castelli Gallery, New York (photograph by Rudolph
Burckhardt). The slit slashes of felt in different colors project a luxuriously
swinging rhythm with a lyrical beat all their own.

99 Robert Morris *Untitled*; 1964, painted wood, photograph courtesy Leo
Castelli Gallery (photograph by Rudolph Burckhardt). There can be no
doubt at all about the sheer environmental presence of this piece by Robert
Morris.

learn all we can about these new developments in the significant
creative painting of our time.

In the end, we cannot help but wonder what will come next. No
one really knows. It is better that way. But, we may count on the
fact that artists will not stop. New forms will emerge. It will not
be long before we get to hear about them and then, get to see them,
and, depending upon how important it all is to us—in time, come to
know and feel what they are all about.

Index

2380

759.06 Wasserman, Burton
WASSERMAN
 Modern painting:
 the movements, the
 artists, their
 work

$11.95

DATE			
JAN 1 4 1982	NOV 20 1986	OCT 2 1 1992	
FEB 4 1982	MAY 2 1 1987	Tsovtsovris	
MAR 1 8 1982	KROL	MAR 2 3 1995	
OCT 1 3 1983	JAN 2 5 1990	APR 7 1995	
MAR 1 5 1984	MAR 1 5 1990		
DEC 6 1984			
NOV 2 1 1985			
APR 1 7 1986	MAY 2 4 1990		
OCT 2 9 1986	NOV 2 1 1991		
	JAN 0		